CALARTS
Skeptical Belief(s)

Organized by
The Renaissance Society at The University of Chicago
in cooperation with the
Newport Harbor Art Museum

CURATOR:

Susanne Ghez, Director
The Renaissance Society at The University of Chicago

ESSAYISTS:

Catherine Lord
Douglas Huebler
Howard Singerman
John Miller
Mark Stahl
Susan A. Davis
Stephen Prina

Copublished by
Newport Harbor Art Museum,
Newport Beach, California, and
The Renaissance Society at The University of Chicago,
Chicago, Illinois.

CalArts Skeptical Belief(s)
is an exhibition organized by
The Renaissance Society at
The University of Chicago, Chicago, Illinois,
in cooperation with the
Newport Harbor Art Museum,
Newport Beach, California

The Renaissance Society May 6–
at The University of Chicago June 27, 1987
5811 South Ellis Avenue
Chicago, Illinois 60637

Newport Harbor Art Museum January 24 -
850 San Clemente Drive March 20, 1988
Newport Beach, California 92660

At The Renaissance Society the exhibition was
made possible by significant funds from the
National Endowment for the Arts, a Federal
agency; the Illinois Art Council, a State agency;
and Art Matters, Inc., New York.

The Newport Harbor Art Museum
is supported in part by grants from
the National Endowment for the Arts, a Federal agency;
the California Arts Council, a State agency;
the County of Orange; and the City of Newport Beach.

Library of Congress Number 87-62752
ISBN 0-917493-10-9

Produced by Newport Harbor Art Museum
Editors: Jeanne Dunning and Sue Henger
Design: Sandy O'Mara
Manufactured in Singapore by DCS Pacific Services

Photography by:
Susan Einstein p. 38, 45
James Franklin p. 35
Gene Ogami p. 48
Douglas M. Parker Studio p. 36, 41, 47
Tom van Eynde p. 18, 21, 22, 23, 24, 25, 29, 30, 31,
40, 43, 50, 51, 52, 53, 54, 58
Zindman/Fremont p. 19

CONTENTS

4 ACKNOWLEDGMENTS

5 FOREWORD

6 ESSAYS

History and History by Catherine Lord
Comments on CalArts by Douglas Huebler
Jeremiad by Howard Singerman
Please Pass the Orb by John Miller
Towards an Appreciation by Mark Stahl
Untitled (Man, School, Shoe) by Susan A. Davis
By These Walls by Stephen Prina

17 PLATES

Carl Affarian
Gary Bachman
Dennis Balk
Cindy Bernard
Ashley Bickerton
Ross Bleckner
Barbara Bloom
Troy Brauntuch
Beth Brenner
David Cabrera
James Casebere
David Chow
Dorit Cypis
Dana Duff
Tim Ebner
Kate Ericson & Mel Ziegler
Eric Fischl
John Franklin
Jill Giegerich
Jack Goldstein

Fariba Hajamadi
Jim Isermann
Larry Johnson
Mike Kelley
Julia Kidd
Jonathan Lasker
John Miller
Andy Moses
Matt Mullican
Marc Pally
Lari Pittman
Stephen Prina
Tom Radloff
David Salle
Jim Shaw
Susan Silas
Mark Stahl
Mitchell Syrop
James Welling
Christopher Williams
B. Wurtz

FILM AND VIDEO ARTISTS
Ericka Beckman
Kirby Dick
Sharon Greytak
Linda Tadic
Linda Wissmath
John Caldwell
Ben Chase
Ken Feingold
Kim Ingraham
Corey Kaplan
Jeff Kessinger
Sherry Millner
Tony Oursler
Susan Peehl
Rea Tajiri
Mary Ann Toman

68 LENDERS TO THE EXHIBITIONS

69 CATALOGUE OF THE EXHIBITIONS

73 BIOGRAPHIES

80 BOARDS AND STAFFS

*A*CKNOWLEDGMENTS Since its inception in the late 1960s the California Institute of the Arts in Valencia has emerged as a highly progressive and influential force for the arts, both nationally and internationally. This exhibition explores the impact of CalArts through the presentation of selected works by fifty-seven of its alumni. It offers a basis for observations concerning a particular center of thought at a particular time in recent art history. The artists are represented by works in a variety of media which have redefined art-making over the last two decades. They engage issues in contemporary art from conceptualism, the influence of the media, appropriation, and site specific installations, to works which question the politics of their own production and distribution.

Essayists were invited to write and to examine the institution's influence from varying vantage points—administration, faculty, and former students. This range of contributors defined a range of attitudes. Not unlike the works in "CalArts: Skeptical Belief(s)," the written contributions are provocative and reflect the paradox of the exhibition's title by continuing the questioning process.

This catalogue and the exhibitions which it addresses are the result of cooperation among many individuals and institutions. Conceived at the outset as an exhibition for The Renaissance Society at The University of Chicago, the project gained strength and breadth by the collaboration of Newport Harbor Art Museum. The Renaissance Society's 72-year commitment to contemporary art, paired with Newport Harbor's major role in the West Coast visual arts community, has led to a fruitful partnership in presenting these artists to a wide audience.

A considerable amount of work has gone into the organization of the exhibitions and the publication of the accompanying catalogue, and we would like to acknowledge the generous contributions of those who have made them possible. We are grateful to the administration and faculty of the California Institute of the Arts for their cooperation in all aspects of this publication and exhibition; to Susan Davis, Douglas Huebler, Catherine Lord, John Miller, Stephen Prina, Howard Singerman and Mark Stahl for their probing essay contributions; to Sue Henger and Jeanne Dunning for their careful and thoughtful editorial preparation; to Sandy O'Mara for the excellence of the catalogue design; and to Pen Robinson for her excellent assistance on the publication.

The Renaissance Society extends special thanks to Stephen Prina for his installation design in Chicago, which transformed the space of the Society to accommodate intelligently and sensitively the work of the artists. His floor plan for the gallery was based on the configuration of the booths at the Chicago International Art Expo which opened simultaneously at Navy Pier. The enthusiastic and interested paticipation of the installation crew of Hirsch Perlman, Mitchell Kane, Joseph Scanlan, Dan Harris, J. Vincent Shine and Tony Plaut merits recognition and renewed appreciation.

The lenders listed in the catalogue deserve special recognition for their support of the artists and for their generosity in sharing their works with us. The many galleries with whom the artists are affiliated provided valuable assistance, and we are grateful for this support, which you will find acknowledged separately in the catalogue.

This project has been greatly strengthened by the diligent work and personal effort of the staffs at both institutions. At The Renaissance Society special thanks are extended to Ann Billingsley, Development Director, Jeanne Dunning, Assistant Director and Education Coordinator, Patricia A. Scott, Bookkeeper and Secretary, and Marilynn Derwenskus and Adam Finkel, Gallery Assistants. At the Newport Harbor Art Museum special thanks are due to Paul Schimmel, Chief Curator, and Dr. Anne Ayres, Associate Curator, for their work in expanding the scope and content of the exhibition for the Southern California venue; and to Betsy Severance, Registrar, Richard Tellinghuisen, Director of Operations, and Brian Gray, Exhibition Designer, for their excellent work in handling and installing the work in Newport Beach.

Above all, both institutions are appreciative of the generosity of our funders. The Renaissance Society owes a particular debt of gratitude to the National Endowment for the Arts in Washington, D.C., to the Illinois Art Council, an agency of the State, and to Art Matters, Inc., in New York, who have provided significant funds to make this exhibition possible. Generous private contributions for this project have been received from The Capital Group, Inc., Los Angeles, Timothy and Suzette Flood, Chicago, and Regents Park by The Clinton Company, Chicago. Indirect support has also been received from the Institute for Museum Services, a federal agency offering general operating support to the nation's museums.

The artists have in every way given time and thought to this project. It has been a pleasure and source of insight to work with them. We remain grateful for this opportunity.

Susanne Ghez, Director
The Renaissance Society at
The University of Chicago

Kevin E. Consey, Director
Newport Harbor Art Museum

FOREWORD

The Newport Harbor Art Museum's ongoing commitment to California art is well known through major exhibitions of such artists as David Park, Vija Celmins, and Chris Burden, as well as the New California Artist series, the Biennial, and the earlier Hester Gallery exhibitions. In this our 25th anniversary year and on the threshold of a new expansion period, it is appropriate that we acknowledge the long-term impact California Institute of the Arts has had on the visual arts.

CalArts, without doubt, has become the leading art school on the West Coast. In its encouragement of innovation in contemporary art, it has surpassed such schools as the San Francisco Art Institute, Otis-Parsons, UCLA, Art Center School of Design, and UCI. In the long run, the impact of CalArts may be more far-reaching geographically than that of its illustrious predecessor, the San Francisco Art Institute. Clearly, the international reputation of several artists in the exhibition, including David Salle and Eric Fischl, is indicative of the stature of the CalArts program. Of even greater interest, perhaps, is the fact that many of the emerging artists are doing first-rate work that both reflects and critiques these times; they will surely become increasingly important in the future. The influence of CalArts on art in the last part of the twentieth century may be matched only by that of the Art Student's League in New York. Fifty years from now, the time may come when equating John Baldessari with Hans Hoffman, with respect to their persuasive impact on the students of their decades, may not be so far-fetched.

The direction of art in the latter part of the '80s may very well be marked by this new generation of artists. It appears that the influence of the founder of CalArts, Walt Disney, is more pronounced than the graduates would like to admit. Here was a man who had great mastery over the public and who was concerned as much with the perception of the product within the community as with the product itself. Similarly, many of these artists have an unusual concern with art outside of the studio experience; the lone, struggling artist in his garret has been replaced by an individual who is commenting on the process, the dissemination, and reproduction of the art work more than in any previous generation. There is almost a ruthless quality in the distanced stance of artists who consider the practice of art not as an isolated, personal, psychological experience, but rather as an activity integrated with the structure and form of current social and political reality.

Participating in this exhibition has afforded us an opportunity to add more works by CalArts graduates to the Museum's collection, increasing our already significant holdings of California art. In the not-too-distant future, there will be permanent collection exhibition galleries at the Newport Harbor Art Museum where the graduates and professors of the San Francisco Art Institute, including Clyfford Still, Mark Rothko, Richard Diebenkorn, David Park, and Elmer Bischoff, will be exhibited in one facility with the professors and graduates of CalArts—John Baldessari, Doug Huebler, Jill Giegerich, Mike Kelley, Lari Pittman, David Salle, and Tim Ebner, to name but a few.

Paul Schimmel, Chief Curator
Newport Harbor Art Museum

HISTORY AND HISTORY

There's usually something odd about projects that attempt to trace artists back to the schools which produced them. First, such efforts tend to the self-serving, teachers and students being ethically and emotionally obliged to backscratch. Second, artists are conventionally supposed to be born, not made. (Otherwise, anyone could figure out that the supply of art objects can be manipulated to exceed demand.) Information that tempers this romantic notion is usually trivialized as secondary, if not entirely irrelevant, to the ever-sacred art object. Historical, biographical, and pedagogical facts about artists are nonetheless consumed with fascination in private. This is why the functional relevance of, say, Black Mountain College to contemporary art is not so much movement as soap opera.

Since history is a project that need always be attempted, I'd like in these circumstances to avoid soap opera as well as public relations. I want instead to make a few reasonable and affectionate observations about the School of Art at CalArts, or, more precisely, about the program in art and the program in photography, the institutional divisions of the school of art (lower case from here on) which between them trained the artists who produced the work shown here.

CalArts was founded by a shrewd businessman whose idealistic side ran to community planning and social control. Walt Disney's most publicized, and least enduring, vision of CalArts was a sort of platonic interdisciplinary beehive in which creative minds would "pollinate" other creative minds. Though the edifice was never physically completed, Disney's least publicized, and perhaps most enduring, vision of the place was a "shopping city of the seven arts," placed just off the major Los Angeles-San Francisco freeway to relieve motorists of their cash. Disney planned to sell in boutiques lining the circumference of this proto-mall everything from movie tickets to wallpaper, from ballet slippers to replicas of the Taj Mahal. The goods would, to the greatest practical extent, be produced cheaply or free by students, that is, the tuition-paying workers slated to inhabit the center cells of the proposed complex. In the visual arts, motorists would be offered "tomorrow's masterpieces at today's prices."

The school of art is exceptional but not unique among North American institutions. As in certain other art programs of approximately the same age (the Whitney Program and the Nova Scotia College of Art and Design immediately come to mind) a classic guru-apprentice relationship was introduced to the politics of anarchy. The educational setting engendered by this encounter admits both a belief in individual creative genius and a theoretically based critique of cultural production. The many ensuing contradictions (even the rhetorical systems clash) are lived.

The school of art isn't a static entity. The faculty, students, and administrators comprising it change. The only continuity in the school's stated philosophy has probably been to encourage using the place as a site for argument about what contemporary art production might entail, rather than as a place to repeat received behavior. The argument is, and has always been, both vehement and skilled. If the school is a place for argument, this means that there is no single "school of art." It also means that the school has never been a one-man (or woman) show, thought there have been occasional pretenders and many conspiracy theories. All battles for ideological and esthetic domination of the school have failed. Teaching is a collective activity in the school of art, paradoxically tested and tempered by the artistic production of individuals. Neither theory nor practice is taken for granted. This creates a process that isn't comfortable and isn't euphemistically "pluralistic." It is something that makes the school of art a serious place to get work done, for students and faculty alike.

Though this setting is one reason for the exceptional success of school of art graduates, it's important not to conflate success with market value or critical recognition. The range of work produced in the school of art and the lives and careers pursued after leaving it are far broader than this exhibition can convey.

The most important changes in the school may not be the obvious twists in style. For example, one crude chronology goes as follows: begin with the odd coexistence of painting, multi-media event, and feminism, go on to the loose alliance called "conceptualism," and

> *"The educational setting…admits both a belief in individual creative genius and a theoretically based critique of cultural production."*

then to more recent concerns with originality, appropriation, and the politics of representation, this last aspect being almost disproportionately represented in this show. There are, however, other shifts. One of the most important is the changing relation of declared political concerns, particularly feminism, to the school of art. The most famous program ever conducted under the auspices of the school of art, so far as I can judge by the mail it *still* receives, was the Feminist Art Program run by Judy Chicago and Miriam Schapiro. The program, along with a first generation of feminist artists, was expelled from the school of art in the mid-70s with virtually biblical fanfare, effectively leaving it with an all-male faculty. This didn't, of course, stop women admitted to the school from producing art; far from it, some of the strongest women showing in this exhibition attended CalArts when no women taught there regularly. The expulsion did, however, entail a reassessment and reinvention of the relation between politics and art production. As a result, in the late '70s and early '80s more women began to be hired, feminists among them, in part because those were the years when radical was still somewhat chic in the art world.

That change is having an effect which isn't fully visible, though there are symptoms. In the days when the faculty was male, for instance, the word "mentor" was apparently used with tranquility as a synonym for "instructor." Now that "mentor" is being sold to women as a brand of condom, the educational assumptions the term contains will be reevaluated: market research always has an effect on the art world. This is perhaps only to point out that relations between postmodernism and feminism are strained, the latter being more useful to the former than the reverse.

Catherine Lord

Catherine Lord is a writer and Dean, School of Art, at CalArts.

COMMENTS ON CALARTS
When the Conceptualist enterprise was launched in the late 1960s, it was generally received as a radical assault against late Modernism and its Formalist methodologies. On one hand, however, some artists responded positively to its implications and were quick to exchange their paint brushes for cameras, while the more stouthearted stood their ground and carried on the effort to solve formal problems in order to further expand the "language of art."

From my point of view, artists who felt threatened by Conceptualism, or simply discounted it, failed to recognize the fact that its essential ambition was to vastly enlarge the subject matter of art by creating modes of representation for phenomena that Formalism had had no way to "picture," e.g., time, tide, ideas, infinity, sociopolitical realities, etc. So everything—all categories of things—could henceforth be regarded as the subject of art, with language functioning as the glue binding together the construction of a given work.

During the same period of time, the war in Vietnam was producing the impulse behind all manner of serious challenges to extremely problematic, socially sanctioned, and institutionalized attitudes concerning race, education, sexual prac-

"So everything—all categories of things—could henceforth be regarded as the subject of art..."

tice, and gender-related issues. I certainly don't mean to suggest that action on those issues was not in place before the Vietnamese war, but there is no question that the war accelerated further action. Most certainly, by the end of the '60s, a generation of young Americans saw that Richard Nixon's and Spiro Agnew's "Middle America" and "Silent Majority" constituted a morally and ideologically bankrupt "Establishment," an institution the ideologically "aware" of that generation wanted to distance itself from. Many sought to identify with a more morally sensitive ideology and imagined its presence in the practice of art, so they chose to be artists, certain that art provided the only platform upon which they could stand and speak out about personal or public issues. More importantly, for the first time the "speaker" was not required to speak the "language of art."

As a consequence, since the early '70s we have seen an increasing amount of art produced by people who are undeniably creative despite the fact that they have no talent for the proper rendering of anatomy or perspective, artists whose example persuaded more and more art programs to accept students whom they never would have considered in the old days.

Most schools, colleges, and universities were slow to change their admissions policies, slow to alter teaching philosophies or to loosen the structure of their courses. In that regard CalArts was in the right place at the right time. It opened its doors in the early '70s, informed and responsive to the dynamics of change I have briefly described above. We are now able to see the fruit of the CalArts approach in the output of its alumni as these young artists reach mid-career.

Part of that approach can be described by the fact that we do not move students through a rigid, organized series of courses. There is just plain "Painting," for example, no "Beginning," "Advanced," or "Graduate" painting courses. The

student may take Painting as many times as she, or he, chooses, whether with the same instructor or a different instructor each time. Undergraduates and graduate students elect the same courses and seminars, bouncing off each other in discourse. It is a flexible, relaxed, serious, organic approach that results in what I would call a high degree of "cross fertilization." In the long run it is the students who create CalArts. They challenge each other, learn from each other, and are highly supportive of each other, especially after they leave CalArts, when they are seen, like members gathering at a family reunion, whenever a former colleague has an exhibition in New York or Los Angeles.

I've tried to make these comments in a tone of voice that doesn't sound as if I'm writing our *Bulletin*, so I just scanned a recent one to check on myself and I ran across the following: "No one knows exactly what it takes to make an artist." So, I wonder "what *kind* of artist? Good, serious, successful?" I think we've had them all in different people and maybe in the same person. Then again, I'm not certain. I also wonder about the fact that we draw our student population from a far different generation than existed when we opened. The sociopolitical climate is different and seems only to have inspired the birth of Yuppies. The art market is hotter than ever, ready to consume new artists as fast as they "emerge." CalArts may have been in the right place at the right time in 1970, but the times they are a-changin! We feel pretty good about where we've been and what we've done, but I don't see any way that we can sit comfortably on our past. I think that we're still faced with the question of "(how) to make an artist."

Douglas Huebler

Douglas Huebler is an artist and Director, Program in Art, at CalArts.

JEREMIAD

An anecdote: In a class I was teaching on Art Since 1945, I tried with some fervor to suggest how Rothko's work might work, how the paintings might reflect, even if they fell short of, the painter's highly rhetoricized desires. The question one student asked afterward has inscribed within it a sweeping distance as well as a certain hubris: "Wasn't that a little naive?"

My impression of CalArts from the beginning was colored by a sense that I had arrived after the fact. And perhaps it was only my impression, but it seemed that the students who were enrolled then, in 1982, sensed that they too were too late, that they had arrived not only after some flowering of CalArts but after the possibility of art as well.

The critique of the work of art mounted by the generation embodied in Michael Asher, John Baldessari, and Doug Huebler was, for their students, understood, internalized. To them it came naturally. And while the students extended the critique to include its authors—mistrusting the moral and political rightness their teachers assumed in their refusal to make a certain kind of art, and refusing to see their poststudio practices as other than the creation of still more artists—there was no particular liberation, no stance on the promontory of the centuries, in that supersession. After class, one was left with a disbelief in the work of art and an inability to share the belief in the liberating, evangelical power of not making paintings.

It was the critique itself, the uncovering or catching out of a presentation, that could claim rightness when presentation—the work as a positive formulation—could no longer. This opening up of the work of art under interrogation to reveal its bad consciousness continued from pedagogical method to art practice, and it is presumably this trait that gives the exhibition its name. Maybe it is not worth saying, but in school, in practice, the catching out was often cruel, and the skepticism often neither doubtful nor uncertain but, in fact, a brand of positivism. The work was interrogated from the position the truth occupies, which knows what can't be done.

That position was most often occupied by Theory, which here earns its capital T because it seemed there to know no difference. Theories were not brought into play; rather, Theory was owned, and within it Nietzsche, Bataille, Foucault, Deleuze, Baudrillard became one; cited as authorities, they became footnotes for political correctness and, just beyond that, moral rectitude. Beneath the gaze of privileged knowledge, of knowing better, art practice was conceived no longer as a way of thinking in the world (for that investment was now unbelievable, that job now Theory's), but rather as a way of operating in institutions, of occupying positions. (I should say that the best work here splits the difference; it is the artists thinking in institutions, as institutions increasingly realize the world.) Made as something that has been worked on by Theory, the art work was constructed to be taken into the discourse it had been made out of. It knows its place, a critique awaits it. And its consumption is proof of Theory's inescapably encompassing scope.

If the critique of the work of art inherited from the 1970s is founded in the discovery of its economic and textual contingencies in the art world, the traffic in an inescapable art world has become the subject and image of much of the practice here. And again consumption, the full and painless recuperation of the work in a system that predicates its arrival and expects its return, is proof of the institution's evil and its scope—and proof of the artist's savvy, for he has refused the system anything real. In such case, the practices of afterness and disbelief have become familiar (as if being unfamiliar would slow their use): the arch, ironic work that knows too much to be real and, therefore, like Rothko, naive, and the conjunctions of image and text that sign their position beyond style and in science.

It is the task of art schools to create modern artists, that is, to disabuse students of the notions of art and artist with which they arrive, certainly of the various lay definitions of art as craft or personal expression or therapy or entertainment. In this, CalArts is not much different from most art schools, but the task does recall an article written at the dawn of CalArts by former dean Allan Kaprow, "The Education of the Un-Artist." But where Kaprow suggested that the un-artist was a sort of joker in the real, a refuser of categories and expertises, the un-artist now—and in this CalArts is perhaps preeminent—has not been dispersed in the world freed of his name, artist, but rather, as he works on the presentations of others, hyperprofessionalized. If he has become, to use a Kaprow concept from a decade earlier, "a man of the world," it is not because he has engaged the world, but because he manages a career, works his contacts. And if we are to play at skepticism, at normalizing terms and refusing metaphysics, maybe I can say that the artists included in this exhibition are artists now; they are interesting people who make more or less interesting things in the language of their profession; they give those who share the language something to read.

"If the artist has become a 'man of the world'…it is not because he has engaged the world, but because he manages a career, works his contacts."

Perhaps I should continue to state the obvious: CalArts is a fairly good—and by this we all mean a fairly accurate—art school. Some of its students have become good artists, some have learned something, and many have gotten lost or been overlooked in the catacombs; CalArts hasn't salvaged all its students as artists. The faculty ranges from involved to detached and bitter, and their proportionate influence over students is hinged to their careers outside. Far from the urge to the *gesamtkunstwerk* laid out in the school's catalogues ("The future holds bright promise for those whose imaginations are trained to play on the vast orchestra of the artist-in-combination."), the departments are as tribalized and segregated as their professional communities are outside. Within the departments, the dissensions and diversions among faculty form the subliminal texts that understand myriad debates on "real" issues, and leave their traces on student sign-up sheets and advancement committees. And far from the school's self-image as open and liberal, CalArts students have a good deal less to say about hiring and firing, requirements for acceptance or advancement, and financial aid than students at such behemoths as UCLA. If these points of procedure have little to do with art, they are included to force the issue that this show is about the alma mater. One would have thought that the skepticism located in the title would have extended to the exhibition itself.

Howard Singerman

Howard Singerman taught in the Critical Studies Division of CalArts during the period 1982-85.

PLEASE PASS THE ORB
(A Class Role for an Art School)

In one of the more memorable scenes from Woody Allen's "Sleeper," the cryogenic Rip Van Winkle character arrives at a futuristic cocktail party. The guests get mildly intoxicated from rubbing a sphere passed between them and, as things heat up, they slip, one by one, into the Orgasmatron, a kind of Reichian orgone box gone to seed. The hostess, liberated from work by automation, declares that she and her friends have all become artists—and goes on to recite her own McKuenesque verse. What does Woody Allen's prophecy portend? And should art schools be prepared to shoulder the burden of a utopian future?

I got a firsthand impression of CalArts in early 1974—against a background of two years at the Rhode Island School of Design. The two schools were like night and day. RISD ("the Harvard of the art schools") stressed traditional instruction in technique. Lettering, for instance, was made a requirement for freshmen because it "coordinates the hand and the eye." That kind of blinkered empiricism typified the curriculum, its flip side being an ethereal faith in art. Socially, students strove to put on an air of East Coast sophistication. Alcohol, not psychedelics, was the drug of choice. Cool jazz ruled and Swiss watches abounded. When "The Great Gatsby" was being filmed with Robert Redford in Newport, RISD's self-styled elite clamored to appear in the cast as extras. It was more important to be able to project an aura of estheticism than it was to square your ideas against what was really going on in the art scene—which remained something of a mystery. For many, art school was just a finishing school.

But out west at CalArts kids were busy with the "three 'L's": Love, LSD and Led Zeppelin. They had come from the broad reaches of middle America, straight out of a stark teenage wasteland. As an institution, CalArts was definitely a wild card—to the point of near fiscal suicide. A hefty, lump-sum start-up endowment from the Disney family had drawn a swarm of avant-gardists to the faculty. They took over the budget in short order, spending like kids in a candy store. But they were working, professional artists, not bearded, pipe-smoking academics. In the midst of the resulting chaos they forced their students to rethink what becoming an artist might be all about, rather than training them to "ply their craft" quietly and patiently in wait of some obscure personal revelation. For years John Baldessari taught a seminar in "post-studio" art, a tag that even now makes sense despite the resurgence of painting. Characteristically, Baldessari also told students to get out of school as soon as they could hack it. That kind of thing once prompted a *New York Times* commentator to charge CalArts with having turned out a legion of hustlers. But his tacit appeal to the "sensitive soul" argument belies the conflict between productionist esthetics (Duchamp, the minimalists, et al.) and the visual *flaneurie* of paint handling and such. High-mindedness notwithstanding, an artist's rightful focus could only be the existing conditions of the modern market economy, not the old clichés of artistic vocation. What's more, this is all old hat; it's been the case from Impressionism on down.

So students learned to approach their art as something to get done in a fairly straightforward manner. But without an audience, even brilliant work would remain incidental. Publicity became another element to be reckoned with. It is through such utterly middle-class pragmatics as these that CalArts alumni have made a big splash in today's avant-garde.

But "avant-garde" must be qualified; to the extent that it designates steady formal succession, it is completely incompatible with postmodernism. Whatever descriptive power the term retains derives primarily from class opposition, first articulated in the attraction-repulsion between bohemia and the bourgeoisie. Bohemia coalesced in the aftermath of the French Revolution as the bad conscience of newly consolidated bourgeois values. On the one hand, it was populated by the children of artisans and peasants for whom newly won access to secondary education failed to grant upward mobility; they were the first fallout of mass literacy. These, on the other hand, were complemented by a wave of well-to-do dropouts who reviled the strictures of their parents' affluence. How odd, on the face of it, to opt for a life of relative privation! Clearly, prosperity exacted too high a price for some. Whether the work, or way of life, in question could adequately sustain a significant libidinal investment became a sticking point, the distinctive feature. Clearly too, the symbolic role of the artist was overdetermined:

Only in the nineteenth century did...the vague but magnetic image of the artist devoted to his own imagination and self-development emerge as a symbol for the "free subjectivity" that postrevolutionary society claimed to liberate in everyone's life.[1]

That poverty was associated with higher pursuits was, of course, nothing new, given the real or virtual vows of feudal monks and scholars. But the challenge to the social order which it came to represent is distinctly modern. In the antagonistic symbiosis between the two sides, each craved what the other seemingly possessed: a leasehold on security versus the abolition of all restraints. Neither path was wholly satisfactory. Nor would the twain have met. This same insufficiency tears the harried young protagonist of Martin Scorcese's allegorical "After Hours" between the predictable narcosis of New York's Upper East Side and a certain dissolute abandon in Soho (of all places).

Let's place the birth of the avant-garde at the outset of modernism, with Manet. While Greenbergians credit Manet with starting the drive to flatness in painting, his transgression of bourgeois values by way of a formal vehicle is far more resounding.[2] This tendency resurfaced explicitly in Dada, Futurism and Surrealism. But Pop Art, notably, upset the bohemian ethos. Andy Warhol dramatically cast himself in the role of an industrialist capitalist with a demimonde work force. Hence, the Factory. Former CalArts dean Allan Kaprow even published an *ArtNews* article which asked "Should the Artist Become a Man of the World?" But the desire to assimilate the avant-garde into the mainstream has persisted more in the form of isolated didactic gestures than as a viable program. Mobilization (suggested by Hollywood and enacted by Warhol) is the logical course of development, but that development has been arrested. If a collective were to realize the same degree of criticality (class consciousness) as does individualized practice, it would constitute a form of revolutionary action. So at this impasse the avant-garde acquires its definition through marginalization. The paradox, as Bob Dylan put it,

is that, "There's no success like failure, and failure's no success at all." *Embourgeoisment* claimed not only the later Warhol, but also two of CalArts' more illustrious alumni, David Salle and Eric Fischl. Do too well and you're out. Refractoriness has come to typify contemporary practice. By its own nature, the crisis in independent film is sharper. While the genre holds out the promise of a mass audience, shifting economics have torn it apart. Grants continue to dry up. As crossovers like Beth Brenner and Lizzie Borden inch their way toward a blasé ubiquity, holdouts like Yvonne Rainer and Ericka Beckman struggle even harder to make ends meet. So the classic myth of modernist progression conceals a static class opposition: the paralysis of the means of distribution in spite of ever-increasing productive capacity. Here, skeptical beliefs should come as no surprise.

> "...artists must come to regard themselves as bona fide workers with as much connection to society as anyone else..."

One of the avant-garde's pivotal conceits is to arrogate moral authority, purporting, as it does, to be the authentic voice of modernity. This is a source of both strength and weakness. The posture advocates a far greater potential for sublimation than other kinds of art. To accommodate that, the symbolic function of the avant-garde requires a kind of renunciation, a second-order or surplus sublimation, in which the refusal to appropriate material wealth through one's activity becomes analogous to exceeding animal drives. No wonder the image of the satiated artist (as opposed to the starving artist) is offensive, to say the least. But despite the moral clout that comes with the territory, artists continue to disavow any class affiliation. The bohemian legacy might be partly to blame for fostering an illusion of gypsy-like autonomy. But artists must come to regard themselves as bona fide workers with as much connection to society as anyone else, all the more so because art inscribes the right to play within the right to work. The extent to which they fail to do so is the degree to which dandyism overtakes esthetics. If the artist as "fellow traveler" is fated to become either an activist or a tourist, then the choice between finishing school and trade school should be obvious.

John Miller

John Miller is an artist and a contributing editor to *Artscribe International*.

NOTES

1 Jerrold Seigel, "The Boundaries of Bohemia," *Bohemian Paris* (New York: Penguin Books, 1986), pp. 25-26

2 See T.J. Clark's *The Painting of Modern Life* for a nonreductive account of Manet and his times. While pure formalism has rightly fallen into disfavor, political rectitude alone is not enough to produce a compelling art work. The reduction of a statement to its message enforces an instrumentalist use of language which is the antithesis of materialism.

*T*OWARDS AN APPRECIA-
TION: *CalArts' Influence
on Contemporary Art*
Located Acropolis-like on
the crest of a hill overlooking an inter-
state highway, tract homes complete
with a golf course, and surrounding hills
covered with quintessential desert chap-
arral, CalArts invites a profound schism
with its environment. The isolation of
the school from its surroundings readily
becomes the supple metaphorical stuff
with which to reflect on the condition
of the artist in society today. Students at
CalArts were, and are, acutely aware of
the contradiction inherent in a profes-
sion that has been largely legitimated
but which remains essentially socially
marginal. Of course, the cultural value
attached to this profession is to a great
degree related to its very marginalization
within society. While some would con-
tend that this condition is but a reflection
of art's necessary autonomy (read, com-
mitted disengagement), others seek to
correct this condition; they wish to dis-
pel this marginalization of contemporary
art by creating a more meaningful inte-
gration of art practice into a larger seg-
ment of society.

The fundamental contradiction between
art's relative isolation from other cultural
practices and many artists' conviction
that art has an immediate social rele-
vance is, in part, the consequence of the
very institutionalization of the avant-
garde. CalArts, since its founding, has
been beset with this dilemma of the
institutionalization of the avant-garde.
Initially characterized as a laboratory
for ideas and experimentation—it was
explicitly conceived as a sister school
to CalTech—CalArts has since become
identified as an institutional "stamp of
approval" for advanced tendencies in
the arts. Although CalArts is but one
example of this "bringing-into-the-fold"of
vanguard art, it is perhaps unique among
institutions in its ambivalence about
its role as an institutional guarantor of
The New.

A frequently encountered image of
CalArts demonstrates the avant-garde's
own ambivalence about its institutional-
ization: CalArts as the paragon of
vanguard art academies churning out
countless minions who scurry forth to
spread The Official Word from this
expropriatory center for the New York
art world stationed on the West Coast.
This pejorative image is so frequently
encountered as to approach the pre-
scriptive. However, this disparaging por-
trait only confirms CalArts' widespread
effect: its detractors have elevated the
school to the realm of myth.

This exhibition is an attempt to show the
nature and extent of CalArts' influence
on contemporary art. That influence has
become pervasive during the past five to
seven years. This is due to a philosophi-
cal shift toward a more sober, historically
informed, "conceptual" activity in the
art world at large that converges with
CalArts' bias. While this shift is not
entirely reactive, it comes as a welcome
change in the wake of Photo-Realism,
Pattern Painting, Neo-Expressionism and
Graffiti Art.

> *"Students are encour-*
> *aged to understand*
> *their placement within*
> *the flux of history and*
> *the relation of their*
> *work to the evolving*
> *state of art theory."*

Of course, CalArts' influence is most
immediately seen in the quality and
diversity of the work of its alumni. The
diversity of this work demonstrates
CalArts' strength; no officially sanc-
tioned style is reproduced. Yet behind
this diversity there lies an operative
objective tendency. A conceptually
"cool" attitude is shared by these artists,
and it is strong evidence of the profound
influence of CalArts' faculty.

The artists in this exhibition have quite
consciously adopted certain procedures,
strategies and practices which, taken as
a whole, create a critical distance in the
artworks. This critical distance is a mani-
festation of the acute awareness of his-
tory and theory that CalArts promotes.
Students are endowed with a sense of
how history acts on and through their
work. They are encouraged to under-
stand their placement within the flux
of history and the relation of their work
to the continually evolving state of
art theory.

Following are some of the issues, atti-
tudes and concerns that inform the con-
ceptual foundation that supports the
work of many of these artists:

1. The use of appropriation, quotation
and highly mediated forms and presenta-
tion procedures that, taken together,
indicate an historical loss of faith in the
original, auratic[1] work of art.
2. The critique of the notion of progress
in contemporary art, especially as this
notion is unproblematically transcribed
from the concept of technical/industrial
progress.
3. An emphasis on the use of form that
tends to betray its historically deter-
mined status and its culturally condi-
tioned reception.
4. An ongoing interest in the extra-
esthetic, i.e., a conviction that art should
involve more than a continuing investiga-
tion of its own history, forms and prac-

tices. This entails an examination of art's potential social and political engagement. Related to this general concern is the use of forms, means of production and presentation strategies culled from disciplines strictly outside the traditional confines of fine art. For example, consider the widespread use today of commercial photography techniques and conventions within the fine art concept. 5. The adoption of more traditional forms, such as painting, for their history and the intelligibility of their conventions. This movement does not imply a rejection of the ground gained by so-called Post-Studio practices; rather, it is informed by those very practices. Indeed, there has been of late a renewed interest in the use of the overdetermined, discrete, gallery-bound object.

Taken together, these concerns perform a progressive erosion of the notion that art is a universal humanistic discipline. As well, they further undermine the traditional model of the artist as cultural hero. It remains to be seen if this broader critique of the social mythology that shrouds art and artists alike will permeate the art world. Only when the art world integrates the practice of advanced art into a more inclusive historical framework beyond the notion of fashion will the philosophical promise of CalArts be confirmed and its influence fully appreciated.

Mark Stahl

Mark Stahl is an artist who lives and works in Brooklyn, New York.

NOTES

[1] For a full discussion of the term aura see Walter Benjamin's influential essay "The Work of Art in the Age of Mechanical Production," in *Illuminations*, Schocken Books, New York, 1978. Briefly, the aura of a work is all that testifies to the work of art's authenticity, namely the specific situation in which the work is created and experienced, the specificities of the work's physical condition, its placement in time and space, and the work's provenance. Benjamin makes a case that the widespread use of mechanical means of reproduction in modern times has radically undermined the perception of the work of art's aura.

*U*NTITLED (MAN, SCHOOL, SHOE) I first met John Baldessari in September 1973 when I registered for my first semester at CalArts. Because I didn't paint or sculpt but rather thought and documented, he, the head of the Post-Studio department, was my mentor.

As I entered his windowless 8-by-10-foot cubicle in the art office, he rose to only 6 foot 4 of his 6 foot 6 inches, head bowed, as is common for someone who knows how height can frighten—and how low some ceilings are. With the stuttering, incomplete gesture of someone who knows how sweeping even the smallest movement of a 36-inch arm can be, he waved me to the extra chair as he sat down in his.

He was a bit foggy, he apologized; he'd arrived only that morning from Paris. He wore long loose jeans and a pale pink T-shirt the same color as his neck and face. His nose was remarkable but not nearly as grotesque as the molded rubber one pinned in obvious self-deprecation to the otherwise blank white wall. His voice was soft for such a big guy. He wanted to know something about me.

From the Midwest I told him. I attended a private university there, first as an English major because I wanted to be a writer, but I'd gotten involved in the counterculture and covering campus revolutions for the student newspaper, and it was only after the smoke of the last ROTC building had cleared that I realized I wasn't doing anything. So after a year as a dropout I decided to try art school, to rediscover my lost sense of discovery. It seemed the right time, I thought, because of this new thing called conceptual art, where you could do whatever you wanted.

I paused, waiting for the derisive laugh that line usually got, but I didn't get anything close to a laugh.

John had been leaning forward in his chair, staring at something in the air between his eyes and the desk, head cocked as if listening to a voice coming over an intercom. When I paused, he breathed heavily, tossed his head as he often does to preface a thought, and said, simply, gently, "Art often wins by default."

He went on to talk about his own circuitous route to becoming an artist, how he still had to face the work-ethic guilt of his upbringing and that CalArts was valuable for the support it offered. Although, he cautioned, "Tell someone in LA you're an artist and they look at you like you said you were an orchid."

CalArts was the last dream of Walt Disney, a man who entertained millions with and created an empire out of, as Claes Oldenburg once wrote, animals without genitals.

The dream had been of a school that would bring together under one roof all the arts—art, design, music, film and video, theatre, and dance (guess he didn't think much of writing)—for one great ongoing collaborative educational fantasia.

The building where all this was to take place—the physical plant, as it was called by staff; physical planet by students—was an extravagantly large white blocky affair. It had been used—appropriately—in films for location shots of research institutes, hospitals, a laboratory of the 21st century. An antagonist's version of a spaceship defying aerodynamic principles (remember the square wheel?), it isn't so much atop as swallowed by the hill from which it will never lift off. Five stories, 50—or was it 500?—acres of voidal dominance, mostly underground.

In moments of extreme ennui, we'd sit around the cafeteria, delaying the half hour drive home, and joke about how old Walt's dream had failed, and how, if we didn't know for a fact that he wasn't dead but only frozen and hidden somewhere down by the photo lab, he'd be rolling in his grave if he could only see what the school was now.

Because it seemed that, just as he had conceived of twitterpation without titillation or testosterone, he'd also apparently believed in the possibility of collaboration without ego interruption, and CalArts was certainly a collection of extreme egos. It was an isolated community of alienated spirits. It was communal spirits alienated by the common and the comfortable. It was a place where the alienated congregated for a common purpose—to follow their individual dreams.

Scan the cafeteria at lunch time. There are tables of dancers dressed in their underwear, lettuce leaves floating from their plates to their mouths. Music students bouncing in their chairs, tapping rhythms, counterpointing with crunches of carrot sticks and taco chips. The film students, unable to eat unless surrounded by rows of tripods and camera cases. And those theatre students—so noisy!—emoting over their veggie burgers once again.

And the art students? We're the ones on the fringes, the irreproachable ones, unclassifiable, unique individuals one and all. Why, we weren't even students if we didn't want to be. Paul Brach, our storytelling, cigar-chomping, gentleman horse wrangler, New York painter of a dean, a practitioner of the "no knowledge in advance of need" theory of education, believed that we were students only as long as we called ourselves students; artists when we decided to become artists—it was not a title to be conferred.

What was conferred was the sense that we had a responsibility to our own integrity and weren't nobody going to stand in our way—nobody at the school anyway. The freedom was there, the space, the time, and the resources—an impressive display of hardware and an extraordinary assembly of human beings: John Kim Branka David Steve Chris Dede Denny Matt Nancy Ericka Jim Jill, to name only a few.

So there are these two artists sitting in the cafeteria, delaying the half-hour drive home. The theatre students are downstairs doing their weeping willow exercises and the music students are outside recording sounds of the freeway and lawn sprinklers for a new symphony. The room is quiet.

David asks Matt, "Matt, what is a shoe?"

Matt thinks for a moment, lifts a foot, points to one of his oxfords, and says, "This is a shoe, David."

David shakes his head. "No, Matt." He smiles shyly and looks toward the ceiling. Matt's eyes follow.

Matt hears leather brushing against a ribbed sock, hears a heel and sole hitting the floor.

"That, Matt," says David, "is a shoe."

Susan A. Davis

Susan A. Davis is a writer living in New York.

"The dream had been to bring together all the arts for one great ongoing collaborative fantasia."

B Y THESE WALLS
These words come to you as if from a contractor. An exegesis of a common job might seem odd, but this is precisely what I have been called on to do: to discuss the walls designed by me and built for the exhibition as seen at The Renaissance Society in Chicago. This split is strategically maintained in that I accepted this design assignment originally on the stipulation that it not be listed as an art work created by the artist on the occasion of the exhibition but a job requisitioned by the exhibiting institution. (For my other contribution, please consult page 49.)

This assertion is not a moot point and is certainly not an attempt to disavow responsibility or disengage. It is an attempt to resist the fetishization of labor which is prevalent within the esthetic apparatus; not to project work into a position of exteriority where its "purity" may be recouped but to exercise the differences of productivity residing within the utopian dream: the locale of exhibition, the corridors of anonymity as well as inflation, self-imposed or otherwise. Duchamp tried to disrupt the univocal grasp, but the ready-made was seized and returned, dusted-off and idealized. His urinal is destined never to be pissed in again. Tragic. Fixed, locked down and not allowed to move. Of course, it is a fantasy of this dream that it may impute the highest seriousness only to that which is firmly legislated within its boundaries. Split-shifts are not prone to high seriousness, a difficult attribute to maintain when allegiances are divided.

Why is the potential for realizing the promise of labor in art, making good on the bargain, always cut short? Furthermore, in answer to the indictment that this strategy is too political—if only that *could* be the case—would it make it any better (read, politically correct) if that designer, the designer who would have been contracted, inevitably, anyway, remained anonymous and legitimate rather than recognized and illegitimate, illegitimate in that my architectural training is spotty if not nonexistent. The self-righteousness of concealment is not benign.

Historical precedents for this activity are abundant. Because of spatial limitations and preference of approach, a list must suffice: the work of Judith Barry, Marcel Broodthaers, Daniel Buren (especially the writing), Günther Förg, Dan Graham, Claes Oldenburg, with emphasis on Michael Asher's Documenta 7 project, as well as the narrative account of minimalist choreography by Jan Burn and Karl Beveridge in their open letter to Don Judd. But, both for the intelligibility of labor in the esthetic act and its relative obscurity, most important is the 1978 gallery project of Christopher d'Arcangelo, Nick Lawson and Peter Nadin. But, then again, what of Borges' labyrinths and Kafka's hallways? Or, a gesture of tact, what heresy it is to erect this figure amongst Chicago's fine architectural monuments. Forgive me the omissions; demands made by positivist ideology for plenitude cannot always be met.

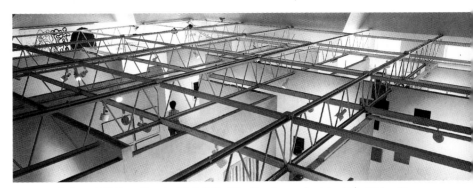

Fig. 1 Installation of "CalArts: Skeptical Belief(s)" at The Renaissance Society at The University of Chicago, May–June, 1987

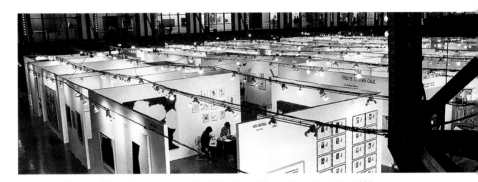

Fig. 2 Installation of the Chicago International Art Exposition at Navy Pier, May 1987

The Cone, I'd said to Hoeller on my arrival, was unique not only in Europe, but it was unique in all the world, never before had any man yet built such a cone, in the course of centuries, in the course of the entire history of building, frequent attempts had been made to build a cone as a habitation, a pure conical shape as a live-in object, I'd said to Hoeller, but no one ever succeeded, not in France, not in Russia, as Roithamer wrote, 'not in France, not in Russia' underlined.[1]

Eleven rooms, five corridors and a foyer (Fig. 1). What logistics of building, what principles of statics, unites this configuration with a purpose? This project differs dramatically from Roithamer's, he being the physically absent yet ever-present protagonist/builder of Bernhard's novel. Rather than the imposition of an idealist plan, the walls became a pragmatic response to a curatorial problem, a response guided by metonymy. The problem, simply stated, is a familiar one: the curator's desire to exhibit more work than may be judiciously accommodated by the existing space. The peculiarities of this exhibition confirmed a related, dual problem: selecting work from a finite set—produced by alumni of CalArts—while arriving at an adequate representation of the Institute's products determined by curatorial prerogative. It is not my concern here whether this representation is comprehensive, to say nothing of correct, but I did understand that the more expansive the selection, the more complete the representation would be. A glib recommendation to replicate the structural subdivisions of the Chicago International Art Exposition at Navy Pier was transformed into a plan of action. My bluff was called. And, considering that the Expo opened the day after "Skeptical Belief(s)," it became the consummate metonym, albeit grounded in metaphor. A bald appeal in the service of use-value is of no interest to me. Nor is the laboratory pursuit of the ideal museum rehearsed at Documenta 8 or the aggrandizement of historical or autobiographical prefigurations. As previously stated, the practical responsibility made accessible through the historical and material conditions of the moment provided the grist necessary to effect a link: Navy Pier/Renaissance Society.

Once established, what can be made of this link between the commercial fair and the temporary exhibition (Fig. 1 and 2)? They blow into town, seemingly take root and then vanish as quickly as they appeared, more or less. Beyond temporality, is the logic of the fair so very different from the logic of the exhibition in that the grid upon which they are organized, one of containment and categorization and issued with the modern age, is shared? Identical symptoms are produced. How else could such an unlikely cohabitation of objects occur on both counts? What could conceivably mark out the appropriate/inappropriate axis? What couldn't be accommodated? And, "consumerism," mouthed as a platitude, is insufficient as criticism. Enough of these models. Take a stroll. Loiter.

…Le Corbusier attributed [significance] to the intellectual experience of the passage through the labyrinth…. Order is not a totality external to the human activity that creates it. When the search for a synthesis is enriched by the uncertainty of memory, by equivocal tension, even by the existence of paths that lead to other than the final goal, one arrives at that final goal in the fullness of an authentic *experience*.[2]

Borges' labyrinth returns, but I cannot defend authenticity. Be that as it may, to speak of experience, from the vantage of the balcony (Fig. 1, entry to which is through the German Language offices. I do not need to measure the velocity of this figure as metaphor, language being the pre-condition for vision, point-of-view, and so forth) the logic of the labyrinth is revealed but in large part the over-100 works are concealed. Only upon descent (into the forest?) are the autonomous elements revealed, while the whole is simultaneously obscured. Each room is a self-sufficient unit with a decor of equanimity, each corridor a cropping device offering vistas, not panoramas. The play of maximum difference of visual proximity is approached in the move from room to corridor and back. I move. I speculate. I fragment. I perform "the complete realization of a constant victory over the uncertainty of the future"?[3]
"I was looking for a job, and then I found a job/and heaven knows I'm miserable now."[4]

Stephen Prina

Stephen Prina is an artist living in Los Angeles.

NOTES

[1] Thomas Bernhard, *Correction*, New York: Aventura, 1983, p. 214

[2] Manfredo Tafuri, *Architecture and Utopia: Design and Capitalist Development*, Cambridge, Massachusetts: MIT Press, 1979, p. 129.

[3] Ibid.

[4] Morrisey and Johnny Marr, "Heaven Knows I'm Miserable Now," from the album *Hat Full of Hollow*, London, Rough Trade; lyrics by Morrisey © 1984.

PLATES

CARL AFFARIAN
GARY BACHMAN
DENNIS BALK
CINDY BERNARD
ASHLEY BICKERTON
ROSS BLECKNER
BARBARA BLOOM
TROY BRAUNTUCH
BETH BRENNER
DAVID CABRERA
JAMES CASEBERE
DAVID CHOW
DORIT CYPIS
DANA DUFF
TIM EBNER
KATE ERICSON & MEL ZIEGLER
ERIC FISCHL
JOHN FRANKLIN
JILL GIEGERICH
JACK GOLDSTEIN
FARIBA HAJAMADI
JIM ISERMANN
LARRY JOHNSON
MIKE KELLEY
JULIA KIDD
JONATHAN LASKER
JOHN MILLER
ANDY MOSES
MATT MULLICAN
MARC PALLY
LARI PITTMAN
STEPHEN PRINA
TOM RADLOFF
DAVID SALLE
JIM SHAW
SUSAN SILAS
MARK STAHL
MITCHELL SYROP
JAMES WELLING
CHRISTOPHER WILLIAMS
B. WURTZ

FILM & VIDEO:

ERICKA BECKMAN
KIRBY DICK
SHARON GREYTAK
LINDA TADIC
LINDA WISSMATH
JOHN CALDWELL
BEN CHASE
KEN FEINGOLD
KIM INGRAHAM
COREY KAPLAN
JEFF KESSINGER
SHERRY MILLNER
TONY OURSLER
SUSAN PEEHL
REA TAJIRI
MARY ANN TOMAN

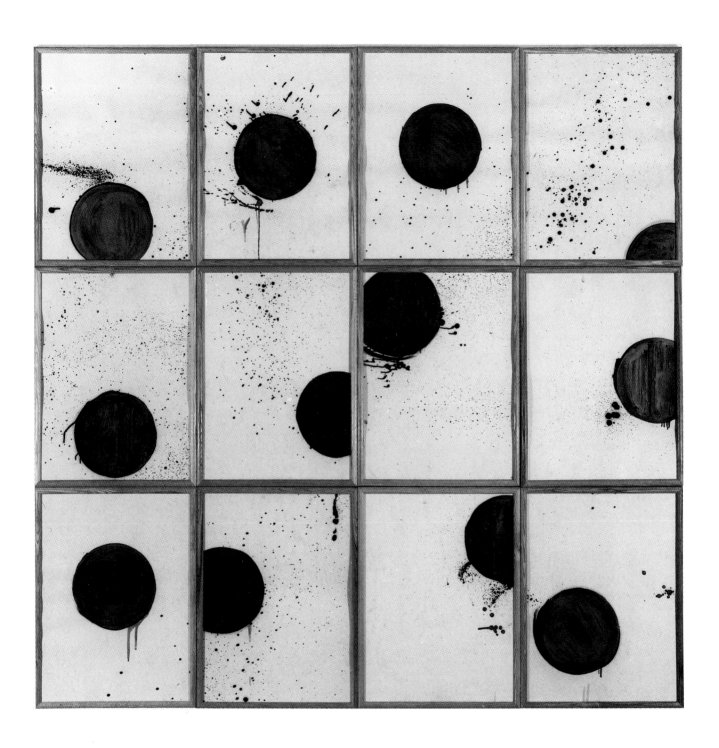

CARL AFFARIAN

The 13th Moon, 1986
oil, gouache on canvas
Twelve panels; 25 x 19 inches each
Lent by the artist
Courtesy of Van Straaten Gallery, Chicago

GARY BACHMAN

You Say Tomato, 1987
Top panel: ink on paper, 19 1/2 x 21 3/4 inches framed
Bottom panel: oil on canvas, 48 x 48 inches
Lent by the artist, Brooklyn, New York

19

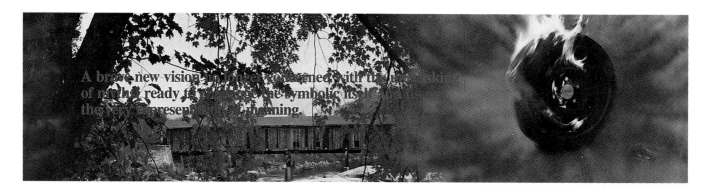

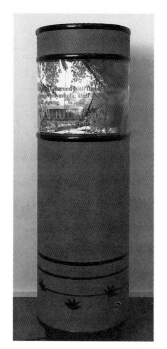 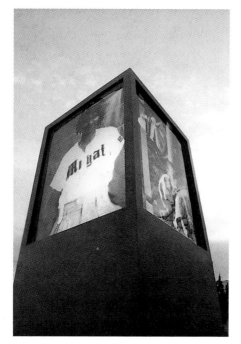

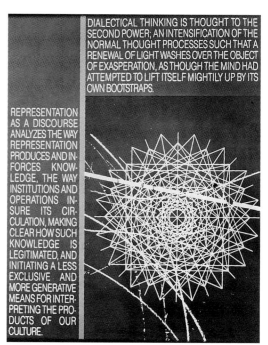

DIALECTICAL THINKING IS THOUGHT TO THE SECOND POWER; AN INTENSIFICATION OF THE NORMAL THOUGHT PROCESSES SUCH THAT A RENEWAL OF LIGHT WASHES OVER THE OBJECT OF EXASPERATION, AS THOUGH THE MIND HAD ATTEMPTED TO LIFT ITSELF MIGHTILY UP BY ITS OWN BOOTSTRAPS.

REPRESENTATION AS A DISCOURSE ANALYZES THE WAY REPRESENTATION PRODUCES AND IN-FORCES KNOW-LEDGE, THE WAY INSTITUTIONS AND OPERATIONS IN-SURE ITS CIR-CULATION, MAKING CLEAR HOW SUCH KNOWLEDGE IS LEGITIMATED, AND INITIATING A LESS EXCLUSIVE AND MORE GENERATIVE MEANS FOR INTER-PRETING THE PRO-DUCTS OF OUR CULTURE.

DENNIS BALK

Top:
Display for a Fall Group Show, 1985 (detail)
fiberglass, vinyl, Duratrans, fluorescent lights
80 x 24 x 24 inches
Lent by the artist, Venice, California
Text: A brave new vision no longer concerned with the unmasking of myths, ready to challenge the symbolic itself and fissure the very representation of meaning.

Second row, left to right:
Display for a Fall Group Show, 1985

Over the Weekend, 1987 (detail)
Formica, Duratrans, fluorescent lights
84 x 23 x 23 inches
Lent by Randy F. Sosin, Los Angeles, California

On Monday or Tuesday, 1987 (detail)
Formica, Duratrans, fluorescent lights
84 x 23 x 23 inches
20 Lent by the artist, Venice, California

CINDY BERNARD

Untitled (dress), 1986
black and white photograph, 2/3
14 x 12 inches
21 Lent by the artist, West Hollywood, California

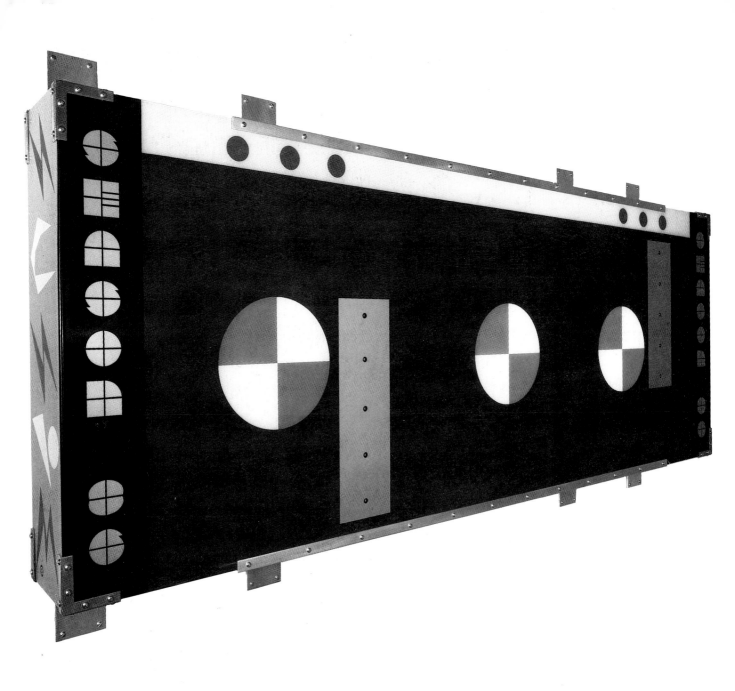

ASHLEY BICKERTON

GOD, 1986
acrylic, aluminum paint, resin on wood with aluminum
48 x 96 x 11 inches
22 Lent by Gerald Elliott, Chicago, Illinois

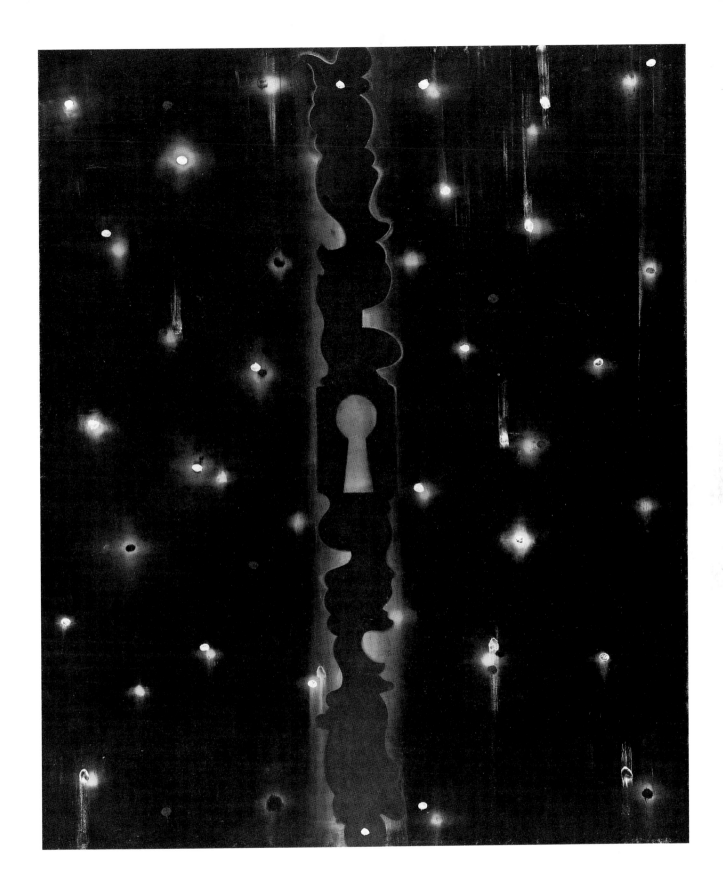

ROSS BLECKNER

Her Escutcheon, 1987
oil on linen
48 x 40
23 Lent by Paul and Camille Oliver-Hoffmann, Chicago, Illinois

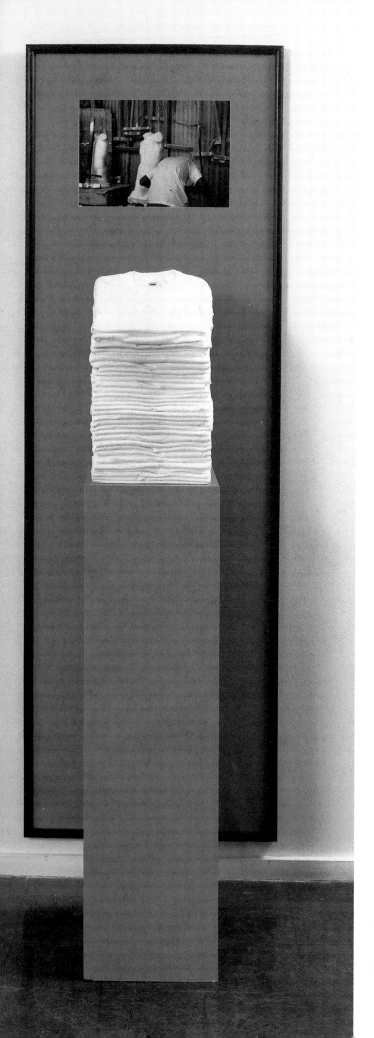

BARBARA BLOOM

Monument to the Male Torso, 1987
mixed media
83 x 26 1/2 inches overall (photograph 79 x 26 1/2 inches;
pedestal with T-shirts 62 x 12 x 12 inches)
Lent by the artist
Courtesy Gallery Nature Morte, New York

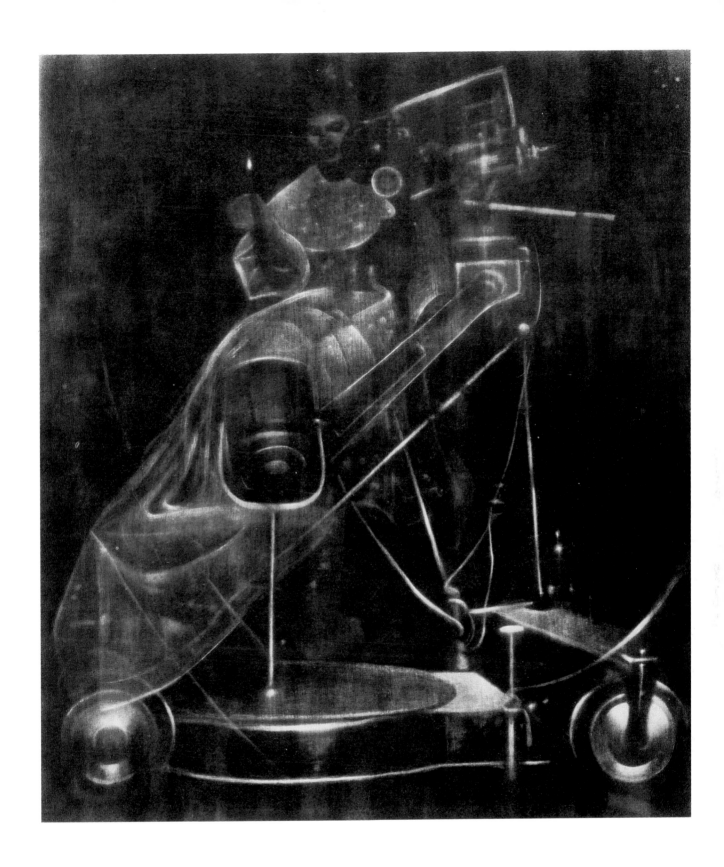

TROY BRAUNTUCH

Untitled, 1986
pastel on linen
96 x 84 inches
Lent by Paul and Camille Oliver-Hoffmann, Chicago, Illinois

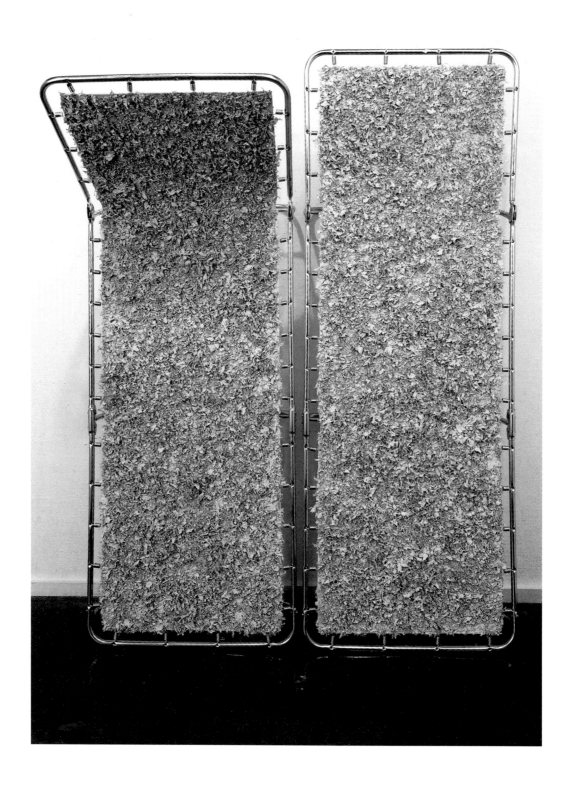

BETH BRENNER

Weekends Only, 1987
acrylic, artificial snow on canvas and aluminum cots
73 x 54 x 27 inches
Lent by the artist
Courtesy Annina Nosei Gallery, New York

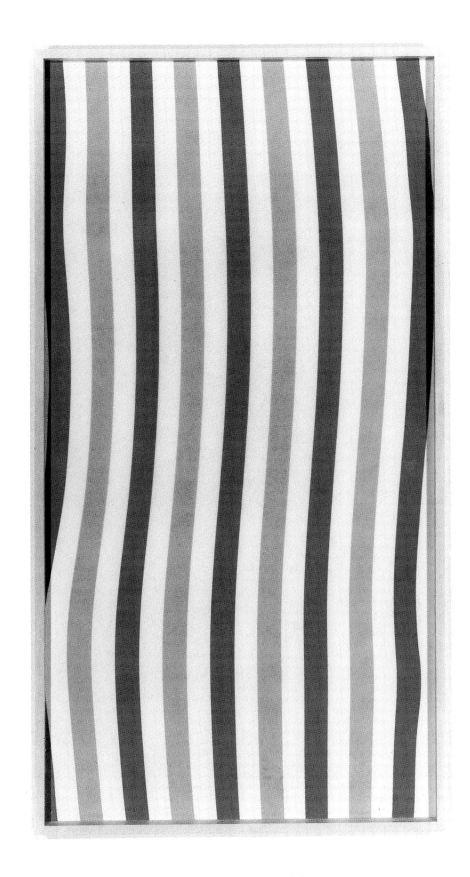

DAVID CABRERA

Polystripe #1, 1986
polyester on birch
61 x 33 inches
Lent by the artist
Courtesy 303 Gallery, New York

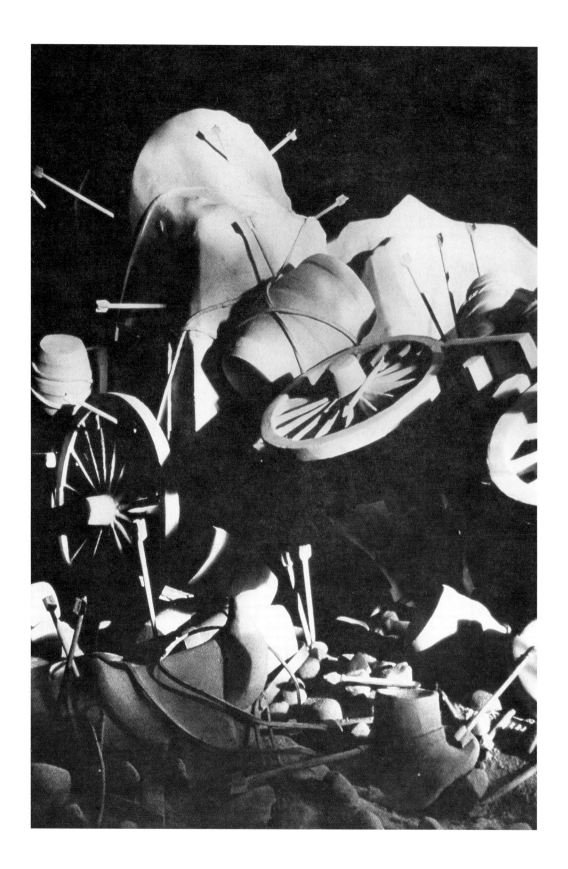

JAMES CASEBERE

Covered Wagons, 1986
light box
55 1/2 x 45 1/2 x 10 1/2 inches
Lent by the artist
Courtesy Michael Klein, Inc., New York

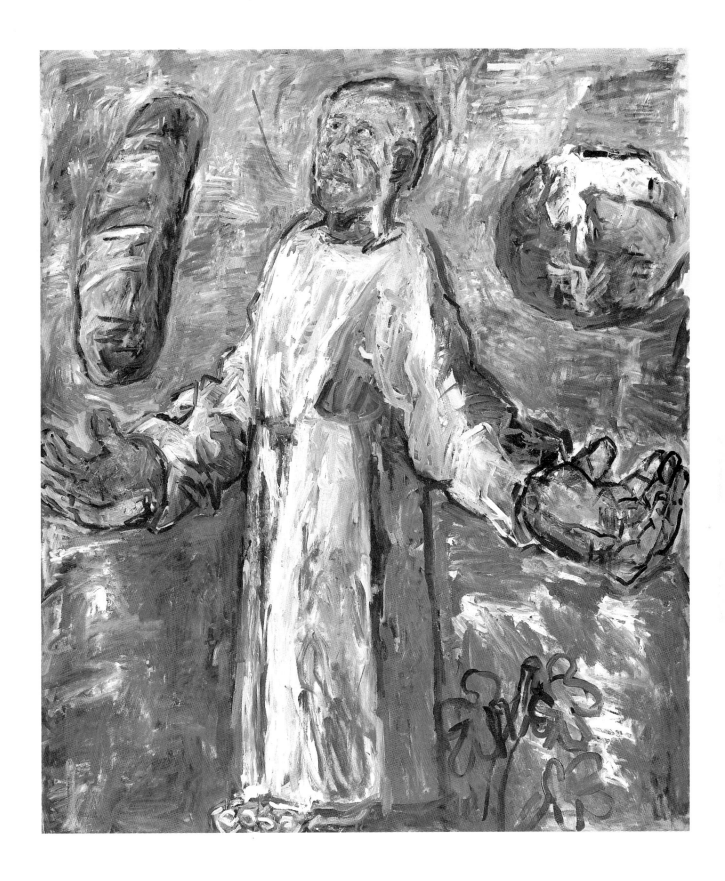

DAVID CHOW

I Can Only Tell Him I Am Hungry, 1987
oil on canvas
84 x 72 inches
Lent by the artist, Brooklyn, New York

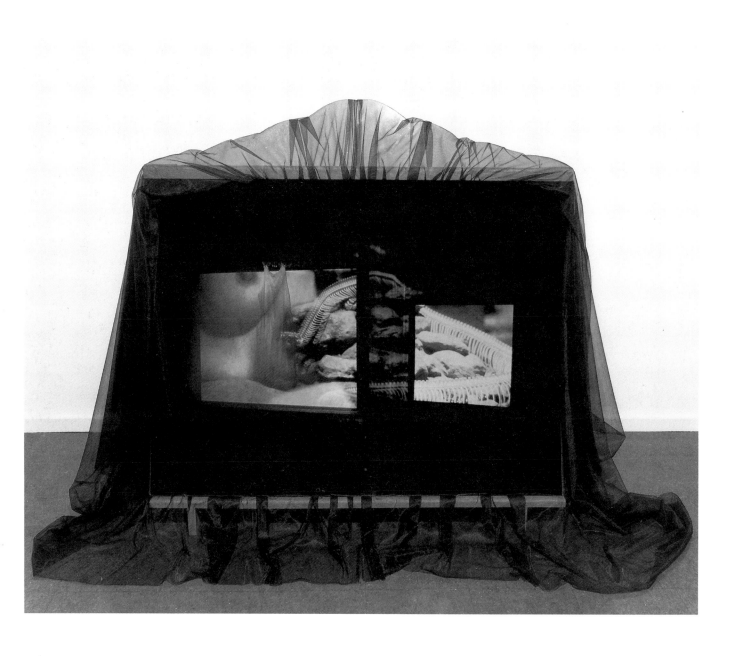

DORIT CYPIS

Recollection, 1987
From a series of nine "Recollections"
Cibachrome, wood, plexiglass, sheer fabric
38 x 40 x 6 inches

Lent by the artist, Minneapolis, Minnesota

DANA DUFF

Background #7. 1985
compressed charcoal on paper
12 x 16 inches framed

Lent by Penelope Milford, Los Angeles, California

TIM EBNER

Color Cue No. 10, 1987
semigloss waterbase paint on canvas
dimensions variable
Collection Newport Harbor Art Musuem

32

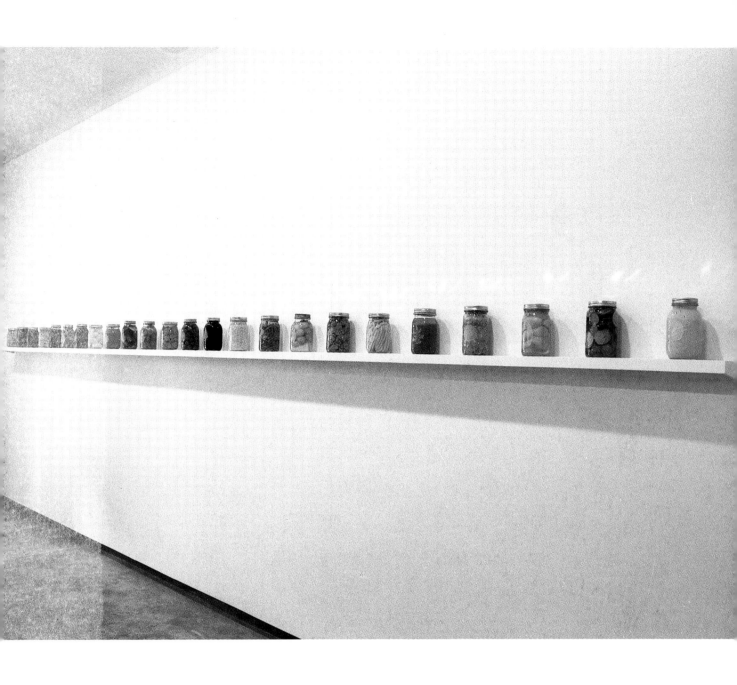

KATE ERICSON AND MEL ZIEGLER

Winter Cellar, 1986
Canned goods from the Pennsylvania Dutch country, sandblasted glass
8 inches x 22 feet x 4 inches
In collaboration with Esther Ziegler; additional contributions from Claire Drescher, Ruth
Drescher, Asa Sensenig, Anna May Stoufer, Josephine Wise, Carol Ziegler, and Jesse Ziegler.
33 Lent by the artists, New York

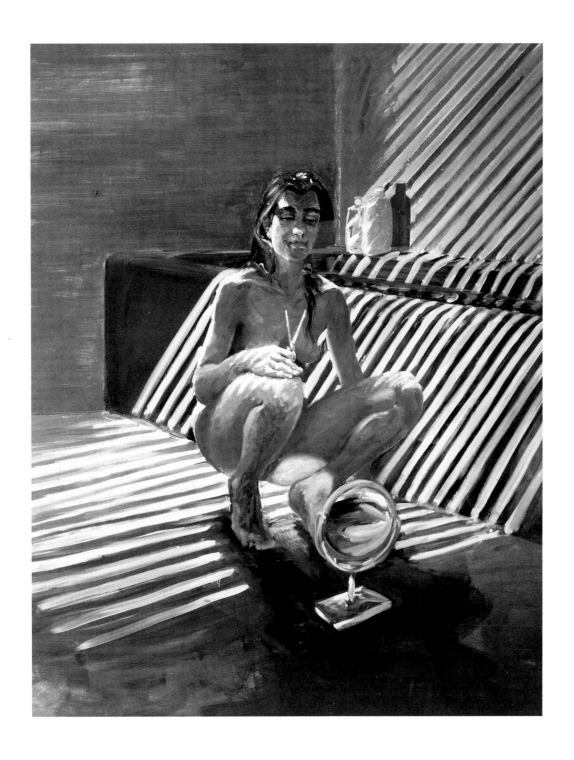

ERIC FISCHL

Haircut, 1985
oil on linen
104 x 84 inches

Lent by the Eli Broad Family Foundation, Los Angeles, California

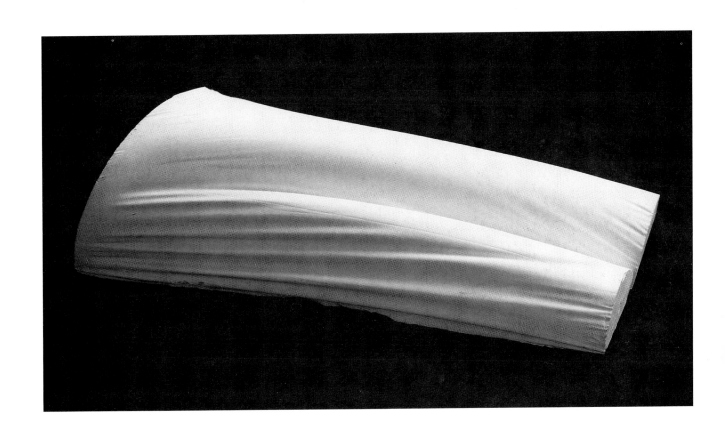

JOHN FRANKLIN

Fold After Cezanne, 1986
plaster, edition of 2
5 1/4 x 19 x 7 1/2 inches
Lent by the artist
Courtesy Loughelton Gallery, New York

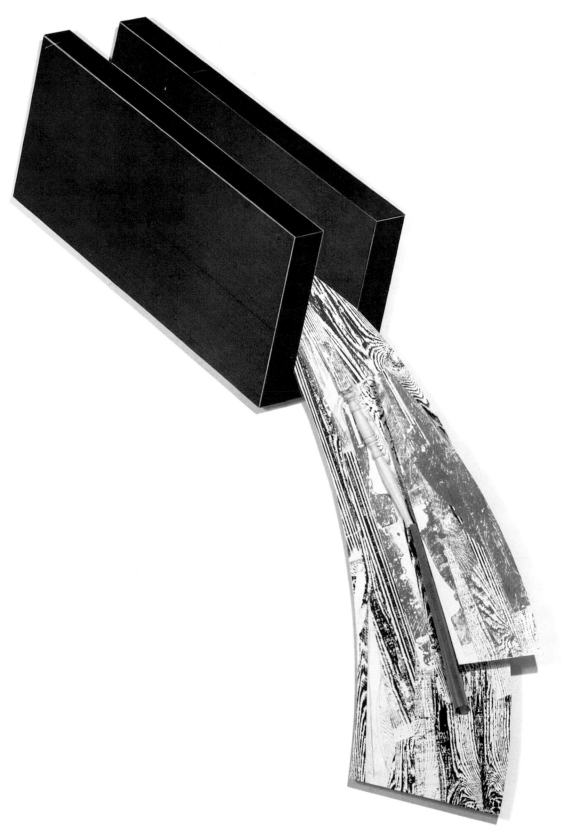

JILL GIEGERICH

Untitled, 1986
vinyl, copper, ink print collage on paper, mounted on wood
106 x 73 x 4 inches
Collection Newport Harbor Art Museum; purchased with funds provided by the Awards in the
Visual Arts (a program sponsored by the Equitable Foundation and the Rockefeller Foundation)
and by the Acquisition Committee.

36

JACK GOLDSTEIN

Untitled, 1987
acrylic on canvas
84 x 84 x 6 inches
Lent by Robert and Michele Newcomer, Chicago
Courtesy Dart Gallery, Chicago

37

FARIBA HAJAMADI

The Telescope With Its Lenses Had Swallowed The Stars, 1987
oil, emulsion on canvas
78 x 40 inches
Lent by Randolpho Rocha, Boston

JIM ISERMANN

Untitled, 1987
enamel paint on wood
48 x 48 x 2 inches
Lent by the artist
Courtesy Kuhlenschmidt/Simon Gallery, Los Angeles

With the war in Vietnam escalating, President Johnson speaks out in support of the conflict, but Bobby opposes this view and eventually decides to run against the President in the forthcoming election. When Johnson announces he will not seek re-election, Bobby is forced to run against Eugene McCarthy. Bobby loses Oregon but he takes California and at the Ambassador Hotel after his rousing victory speech, tragedy strikes and at age 42, Bobby Kennedy is dead of an assassin's bullets.

As the nation mourns the death of their President, Bobby's grief is devastating and he is reminded by Rose Kennedy and his wife Ethel of his position now as head of the family and an important figure in the politics of our nation. Breaking out of his shell, Bobby decides to run for the Senate against Kenneth Keating and, when he eventually triumphs, his confidence and vigor are revived.

LARRY JOHNSON

Untitled (Grief is Devastating), 1985
Ektacolor contact prints
Two prints, left 21 1/2 x 25 1/2 inches, right 25 1/2 x 21 1/2 inches
Courtesy 303 Gallery, New York

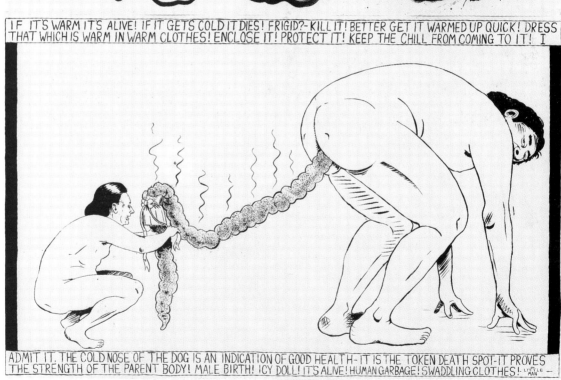

MIKE KELLEY

Trickle Down, 1986 and *Swaddling Clothes*, 1986
acrylic on paper on stretched canvas
Two panels, 60 x 96 inches each
Lent by the artist
Courtesy Metro Pictures, New York, and Rosamund Felsen Gallery, Los Angeles

JULIA KIDD

The Desire and the Doll, 1984
photograph, oil on masonite
60 x 96 x 3 inches
Lent by the artist, New York

JOHATHAN LASKER

The Age of Plastic, 1985
oil on canvas
24 x 30 inches

Lent by M. Sawon and T. Banovich, New York

JOHN MILLER

I Read A Book, 1987
acrylic on canvas
17 x 25 inches
Lent by Bill Komoski
44 Courtesy Metro Pictures, New York

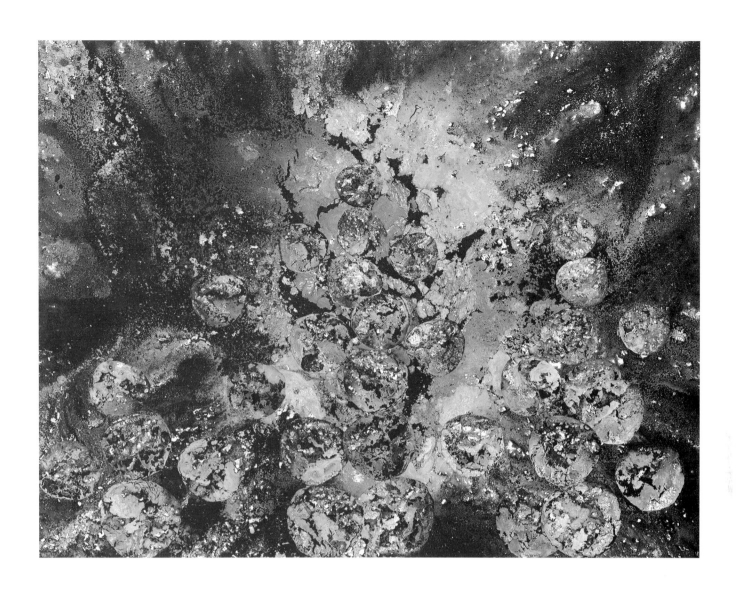

ANDY MOSES

Confessions of Finitude (black), 1987
acrylic, alkyd on canvas
67 1/2 x 90 inches
Lent by Bernard and Rosalie Kornblau, San Marino, California

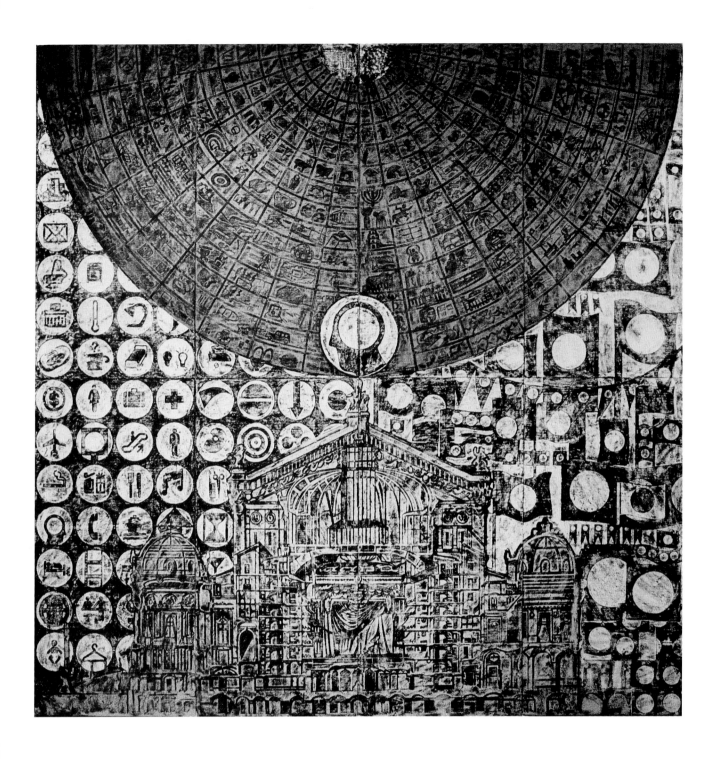

MATT MULLICAN

Untitled (History Over Opera House, Surrounded by Signs), 1986-87
oil stick, acrylic on canvas
192 x 192 inches

Lent by Mr. and Mrs. Robert A. Rowan, Los Angeles

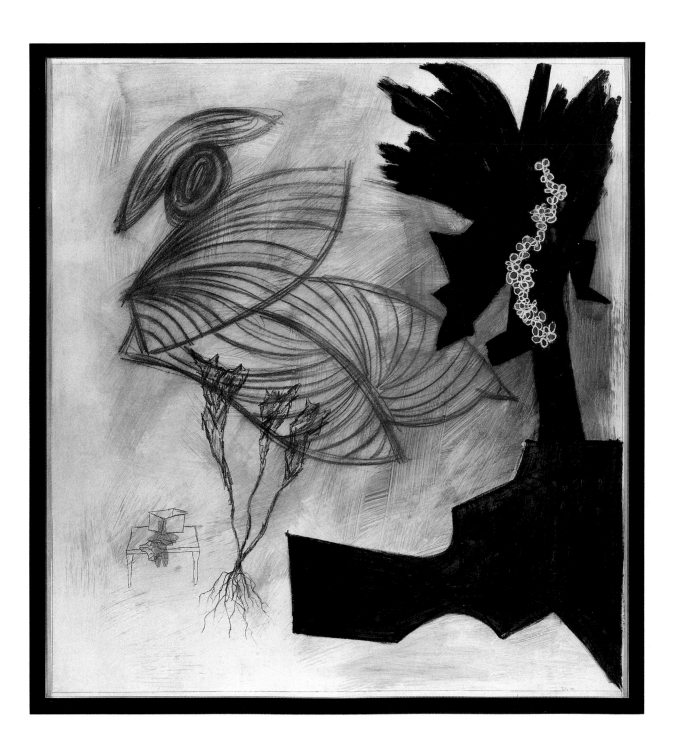

MARC PALLY

Milestone, 1986
oil, oil stick, graphite, colored pencil, oil medium on paper
57 x 60 1/2 inches

47 Lent by Gary and Linda Briskman, Beverly Hills

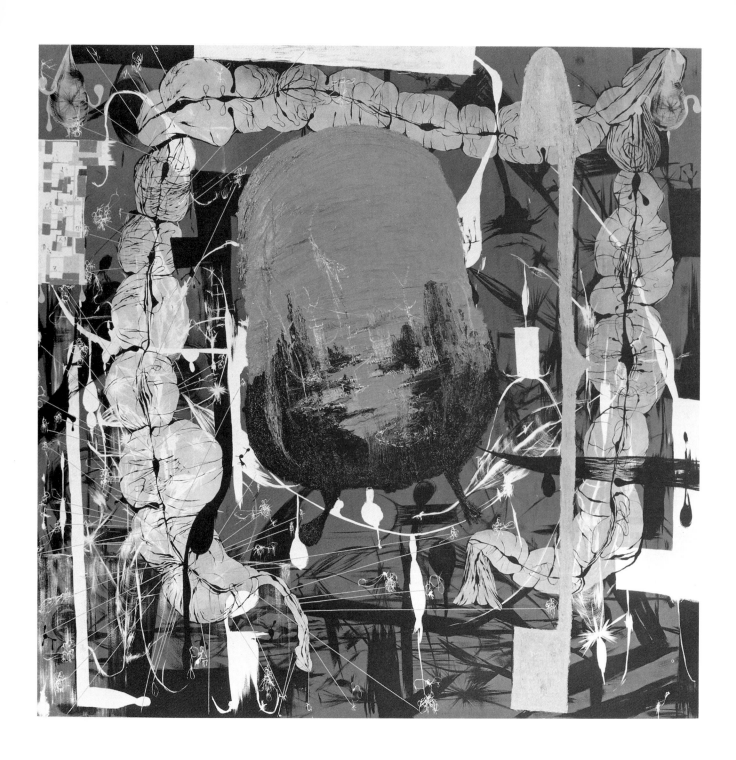

LARI PITTMAN

The New Republic, 1985
acrylic, oil on panel
80 x 82 inches

Collection Newport Harbor Art Museum, Newport Beach, California.

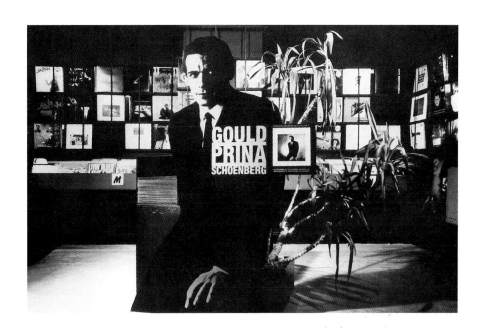

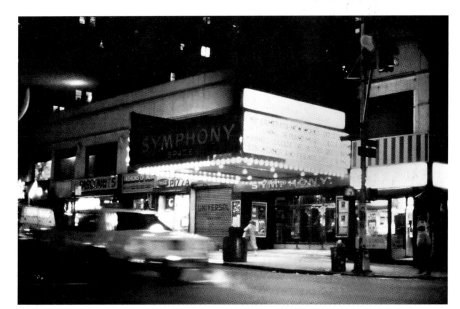

STEPHEN PRINA

Top to bottom:

A Structural Analysis and Reconstruction of MS7098 as Determined by the Difference Between the Measurements of Duration and Displacement, 1980-84 (detail)
phonograph record, photograph, poster, merchandising display, advertisement, rag mat, American walnut frame, catalogue entry
Lent by the artist, Los Angeles

An Evening of 19th- and 20th-Century Piano Music, 1985 (detail)
arrangement for piano, piano concert, program, photograph, poster, announcement, advertisement, rag mat, American walnut frame, catalogue entry
Lent by the artist, Los Angeles

TV Guides, 1986 (detail)
TV Guides, photograph, merchandising display, advertisement, public reading, rag mat, American walnut frame, catalogue entry
Lent by the artist, Los Angeles

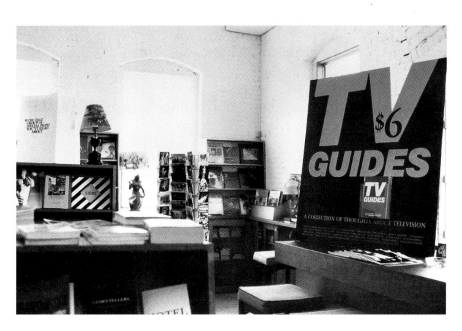

TOM RADLOFF

#4, 1986
waterbase paint, plaster, paper, wood
48 x 32 inches
Lent by the artist

Courtesy Loughelton Gallery, New York

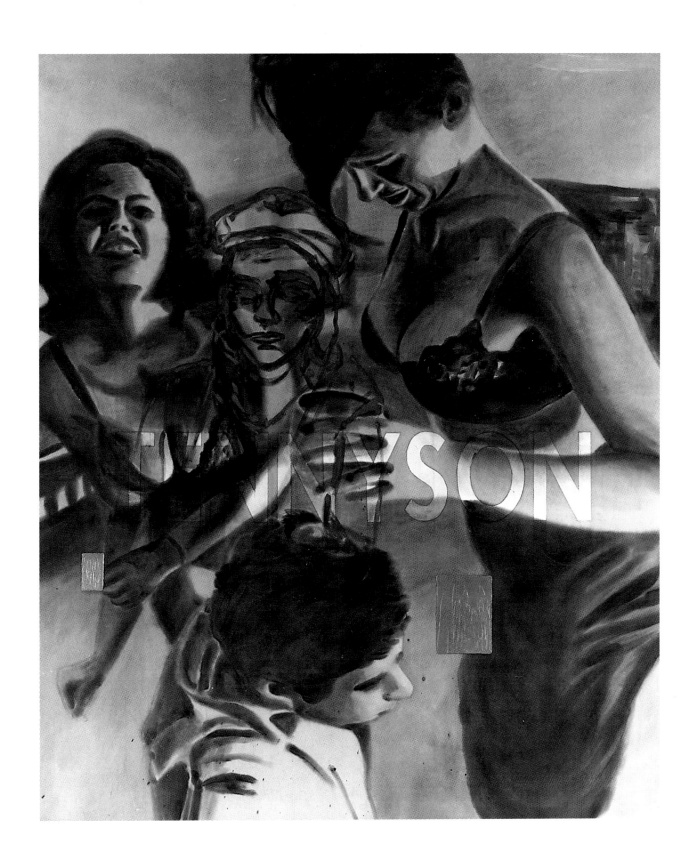

DAVID SALLE

Sexual and Professional Jealousy, 1983
oil on canvas
108 x 90 inches
Lent by Gerald Elliott, Chicago

51

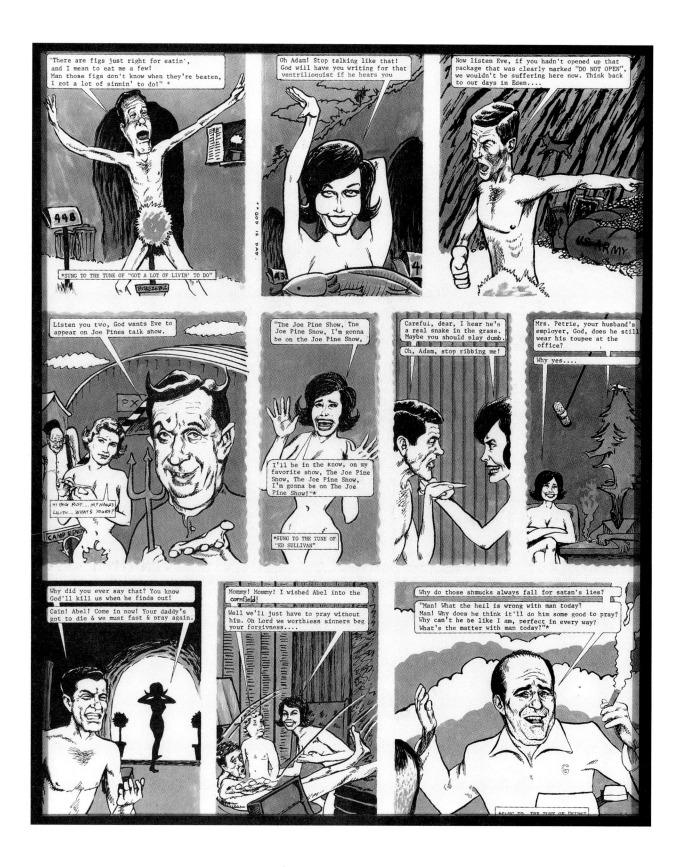

JIM SHAW

The Adam and Eve Show, 1986
ink on duotone board
17 x 14 inches
Lent by the artist, Los Angeles

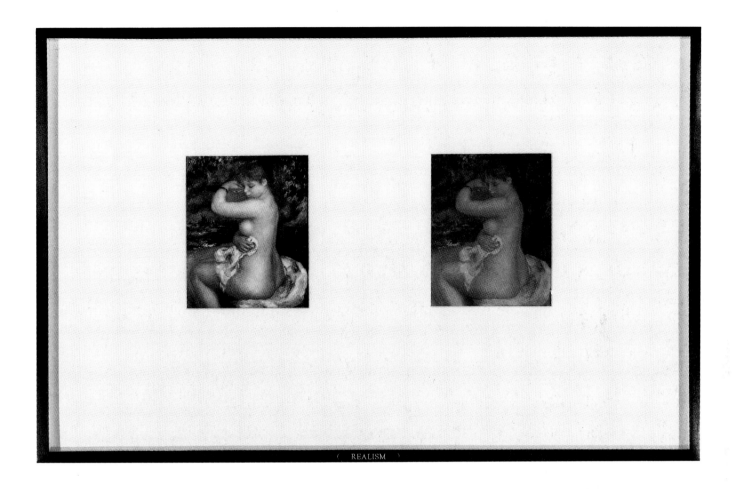

SUSAN SILAS

Realism, 1987
catalogue pages
20 3/4 x 32 3/4 inches
Lent by the artist, Brooklyn, New York

53

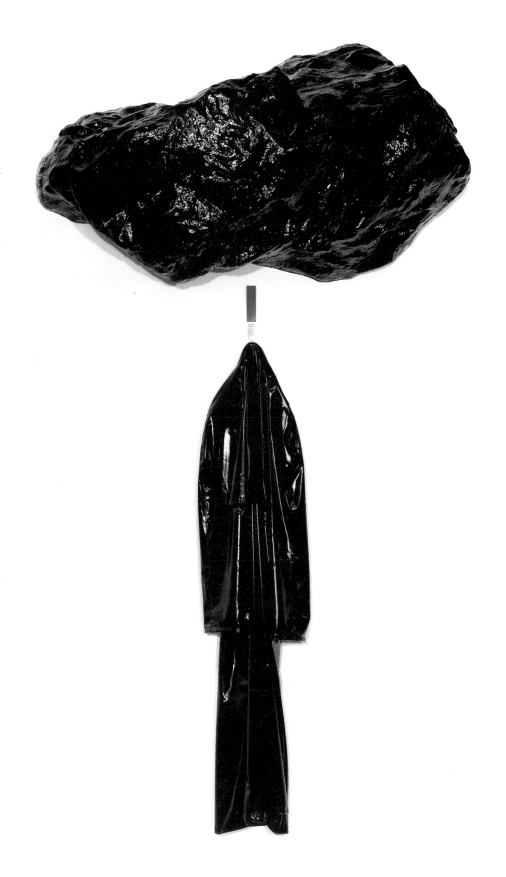

MARK STAHL

The Wet Look, 1987
fiberglass boulder, raincoat, coathook, lacquer paint
96 x 48 x 18 inches
Lent by the artist
54 Courtesy Massimo Audiello Gallery, New York

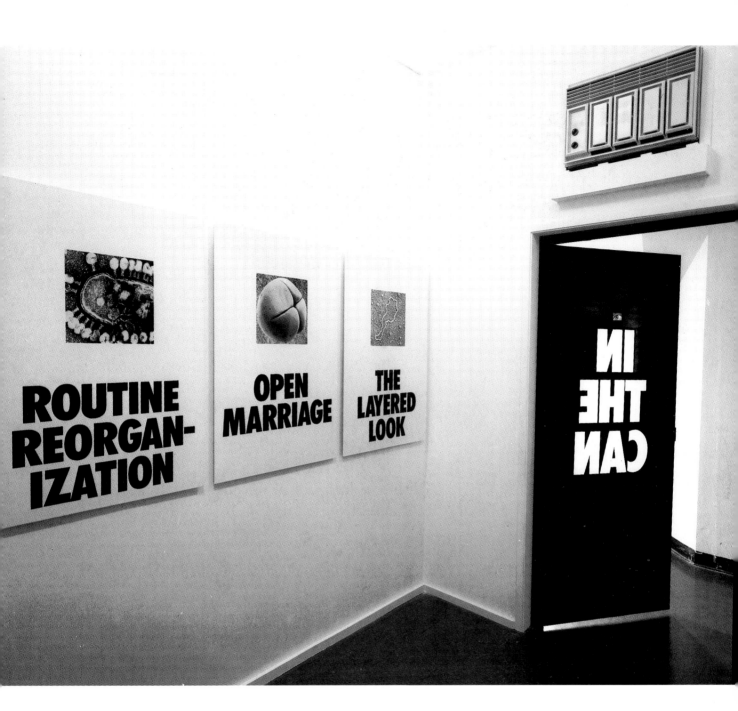

MITCHELL SYROP

In the Can, 1986
installation at The Renaissance Society at The University of Chicago
air conditioner, shower door, black and white photographs
photographs 40 x 26 inches to 40 x 40 inches;
Lent by the artist, Los Angeles
Courtesy Kuhlenschmidt/Simon Gallery, Los Angeles

55

JAMES WELLING

Untitled (69), 1987
vinyl acrylic on canvas
52 x 52 inches
Lent by the artist
Courtesy Kuhlenschmidt/Simon Gallery, Los Angeles

SECONDS

A NEW FILM BY
CHRISTOPHER WILLIAMS,
IS NOW IN
PRE-PRODUCTION.

10:54

MINUTES

THE
RENAISSANCE
SOCIETY
AT THE
UNIVERSITY
OF CHICAGO,
THE CASTLE AT
DOCUMENTA 8,
KASSEL,
WEST GERMANY,
MARGO LEAVIN GALLERY,
LOS ANGELES,
MICHAEL KOHN GALLERY
FOR THE MUSEUM OF
CONTEMPORARY ART,
LOS ANGELES,
AND

NEWPORT HARBOR
ART MUSEUM,
NEWPORT BEACH,
CALIFORNIA,
ARE PLEASED
TO ANNOUNCE
THAT

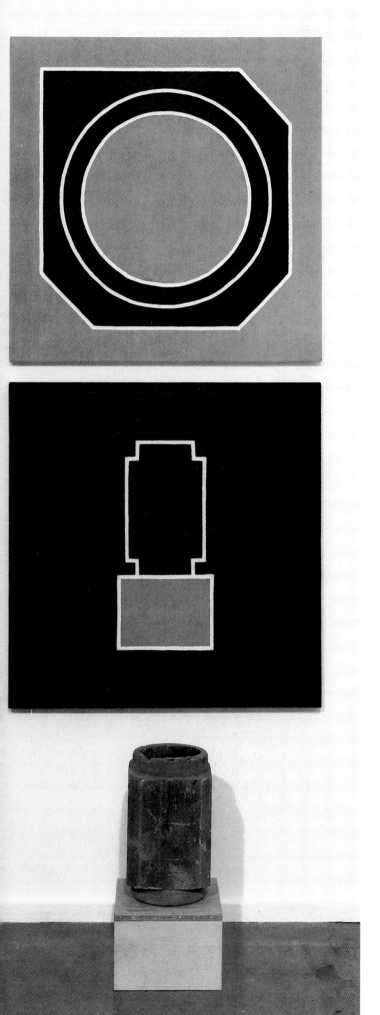

B. WURTZ

Untitled (Vase and Portraits), 1986
mixed-media installation
Three parts: sculpture 18 1/2 x 9 x 9 inches, two paintings 30 x 30 inches
Lent by the artist
Courtesy Feature, Chicago

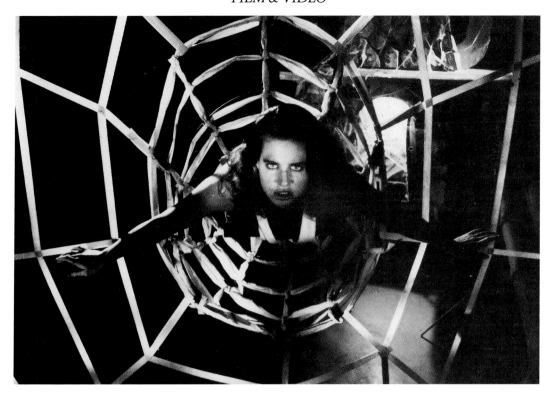

ERICKA BECKMAN
Top: Film still from *Cinderella*, 1986

KIRBY DICK
Bottom: Film still from *Men Who Are Men*, 1981

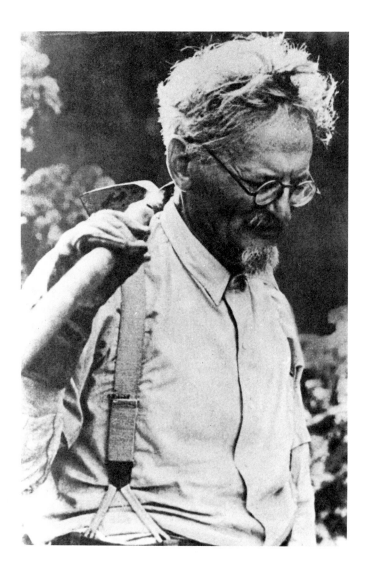

SHARON GREYTAK
Above left: Film still from *Weirded Out and Blown Away*, 1986

LINDA TADIC
Above right: Film still from *Une visite á Leon Trotsky, par André Bréton*, 1986

LINDA WISSMATH
Opposite top: Film still from *The Passion of Joan*, 1983-86

JOHN CALDWELL
Opposite bottom: Video still from *Sightworks Trilogy*, 1984-85

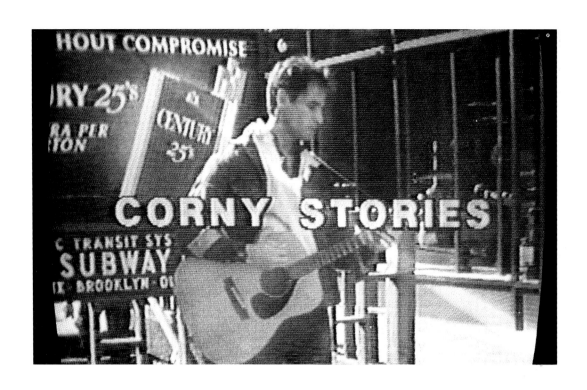

BEN CHASE
Opposite top: Video still from *How Many Elephants Does It Take?*, 1984

KEN FEINGOLD
Opposite bottom: Video still from *Irony (The Abyss of Speech)*, 1985

KIM INGRAHAM
Above: Video stills from *Corny Stories*, 1987

COREY KAPLAN
Above: Video stills from *The Monster Frankenstein*, 1984

JEFF KESSINGER
Opposite top: Video still from *Let Me Assure You*, 1986

SHERRY MILLNER
Opposite bottom: Video still from *Womb With A View*, 1983

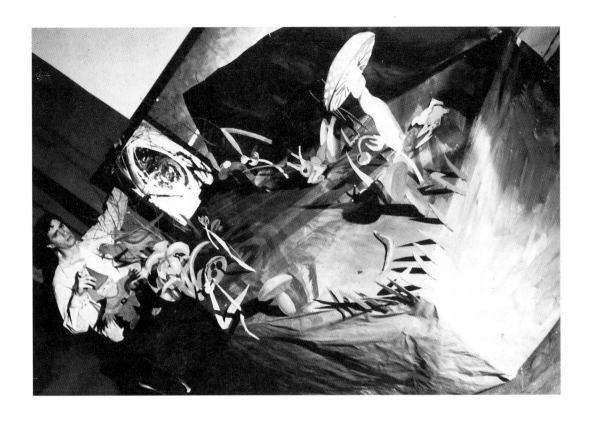

TONY OURSLER

Top: Production photo from *Evol*, 1985

SUSAN PEEHL

66 Bottom: Video still from *You Talkin' To Me?*, 1984

REA TAJIRI

Top: Video still from *Vertigo (3 Character Descriptions)*, 1987

MARY ANN TOMAN

Bottom: Video still from *There Is My Mother*, 1986

LENDERS TO THE EXHIBITIONS

Carl Affarian
Asher/Faure Gallery, Los Angeles
Massimo Audiello Gallery, New York
Gary Bachman
Dennis Balk
M. Sawon and T. Banovich, New York
Adam Baumgold, New York
Ericka Beckman
Cindy Bernard
Ashley Bickerton
Ross Bleckner
Barbara Bloom
Mary Boone Gallery, New York
Troy Brauntuch
Beth Brenner
Gary and Linda Briskman, Beverly Hills, California
Eli Broad Family Foundation, Los Angeles
Eli and Edythe L. Broad Collection
Edward R. Broida Trust, Los Angeles
Christine Burgin Gallery, New York
David Cabrera
John Caldwell
The Carnation Company, Los Angeles
James Casebere
Ben Chase
David Chow
Douglas Cramer, Los Angeles
Dorit Cypis
Dart Gallery, Chicago
Kirby Dick
Dana Duff
Tim Ebner
Gerald Elliott, Chicago
Kate Ericson
Feature, Chicago
Ken Feingold
Rosamund Felsen Gallery, Los Angeles
Eric Fischl
John Franklin
Gallery Nature Morte, New York
Jill Giegerich
Jack Goldstein
Sam and Pamela Goldstein, Laguna Beach,
 California
Jay Gorney Modern Art, New York
Sharon Greytak
Fariba Hajamadi
Kim Ingraham
Jim Isermann
Donna J. Jackson, New York
Larry Johnson
Corey Kaplan
Mike Kelley
Jeff Kessinger
Julia Kidd
Michael Klein, Inc., New York
Bill Komoski

Bernard and Rosalie Kornblau, San Marino,
 California
Kuhlenschmidt/Simon Gallery, Los Angeles
Johathan Lasker
Margo Leavin Gallery, Los Angeles
Christian Leigh, New York
Loughelton Gallery, New York
Victoria Lusk, New York
Metro Pictures, New York
Penelope Milford, Los Angeles, California
John Miller
Sherry Millner
Andy Moses
Ed Moses, Venice, California
Matt Mullican
Robert and Michele Newcomer, Chicago
Newport Harbor Art Museum, Newport Beach,
 California
Annina Nosei Gallery, New York
Paul and Camille Oliver-Hoffmann, Chicago
Tony Oursler
Marc Pally
Susan Peehl
Piezo Electric Gallery, Venice, California
Lari Pittman
Stephen Prina
Tom Radloff
Randolpho Rocha, Boston
Colombe and Leonard Rosenberg, New York
Mr. and Mrs. Robert A. Rowan, Los Angeles
David Salle
Jim Shaw
Susan Silas
Randy F. Sosin, Los Angeles
Mark Stahl
Mitchell Syrop
Linda Tadic
Rea Tajiri
303 Gallery, New York
Mary Ann Toman
Van Straaten Gallery, Chicago
David Vena and Carol Vena-Mondt, Los Angeles,
 California
George Waterman III, New York
James Welling, New York
Christopher Williams
Linda Wissmath
Wolff Gallery, New York
B. Wurtz
Bruce and Norman Yonemoto
Donald Young Gallery, Chicago
Mel Ziegler

CATALOGUE OF THE EXHIBITIONS

*Shown only at The Renaissance Society at the University of Chicago
**Shown only at the Newport Harbor Art Museum
Absence of an asterisk indicates the work was shown at both locations

CARL AFFARIAN

Factora, 1986
mixed media
Two parts, 10 x 3 inches and 15 x 16 x 11 1/2 inches
Lent by the artist
Courtesy of Van Straaten Gallery, Chicago

The 13th Moon, 1986
oil, gouache on paper
Twelve panels, 25 x 19 inches each
Lent by the artist
Courtesy of Van Straaten Gallery, Chicago

GARY BACHMAN

White Man's Burden, 1985
acrylic on fabric
57 x 57 inches
Lent by the artist, Brooklyn, New York

**You Say Tomato*, 1987
Top panel: ink on paper,
19 1/2 x 21 3/4 inches framed
Bottom panel: oil on canvas, 48 x 48 inches
Lent by the artist, Brooklyn, New York

DENNIS BALK

Display For A Fall Group Show, 1985
fiberglass, vinyl, Duratrans, fluorescent lights
80 x 24 x 24 inches
Lent by the artist, Venice, California

**Over the Weekend*, 1987
formica, Duratrans, fluorescent lights
84 x 23 x 23 inches
Lent by Randy F. Sosin, Los Angeles

**On Monday or Tuesday*, 1987
formica, Duratrans, fluorescent lights
84 x 23 x 23 inches
Lent by the artist, Venice, California

CINDY BERNARD

Three By Vera, 1986
black and white photographs, 3/3
Three photographs, 12 x 14 inches each
Lent by the artist, West Hollywood, California

Untitled (dress), 1986
black and white photograph, 2/3
14 x 12 inches
Lent by the artist, West Hollywood, California

Untitled (dress), 1986
black and white photographs, 3/3
Two photographs, 14 x 12 inches each
Collection of The Carnation Company,
Los Angeles

**Security Envelope: E.F. Hutton*, 1987
black and white photograph, 1/3
14 x 12 inches
Lent by the artist, West Hollywood, California

**Security Envelope: Untitled #3*, 1987
black and white photograph, 1/3
14 x 12 inches
Lent by the artist, West Hollywood, California

**Security Envelope: Mrs. Prina*, 1987
black and white photograph, 1/3
14 x 12 inches
Lent by the artist, West Hollywood, California

**Security Envelope: San Jose Mercury News*, 1987
black and white photograph, 1/3
14 x 12 inches
Lent by the artist, West Hollywood, California

**Security Envelope: Museum of Modern Art*, 1987
black and white photograph, 2/3V
14 x 12 inches
Lent by the artist, West Hollywood, California

**Security Envelope: Untitled #4*, 1987
black and white photograph, 1/3
14 x 12 inches
Lent by the artist, West Hollywood, California

**Security Envelope: Margo Leavin Gallery*, 1987
black and white photograph, 2/3
14 x 12 inches
Lent by the artist, West Hollywood, California

**Security Envelope: Department of the Treasury, Bureau of Public Debt*, 1987
black and white photograph, 1/3
14 x 12 inches
Lent by the artist, West Hollywood, California

**Security Envelope: Internal Revenue Service*, 1987
black and white photograph, 1/3
14 x 12 inches
Lent by the artist, West Hollywood, California

ASHLEY BICKERTON

GOD, 1986
acrylic, aluminum paint, resin on wood
with aluminum
48 x 96 x 11 inches
Lent by Gerald Elliott, Chicago

**KHKSHGK*, 1987
bronze powder with lacquer, acrylic,
aniline dye, polyester resin on plywood
with anodized aluminum
18 x 96 x 11 1/4 inches
Courtesy Donald Young Gallery, Chicago

ROSS BLECKNER

**Brothers' Sword*, 1986
oil on canvas
108 x 84 inches
Lent by the Eli Broad Family Foundation,
Los Angeles

**Indian Gift*, 1987
oil on linen
48 x 40 inches
Courtesy Margo Leavin Gallery, Los Angeles

Her Escutcheon, 1987
oil on linen
48 x 40 inches
Lent by Paul and Camille Oliver-Hoffmann,
Chicago

BARBARA BLOOM

Monument to the Male Torso, 1987
mixed media
83 x 26 1/2 inches overall (photograph 79 x 26 1/2 inches; pedestal with T-shirts 62 x 12 x 12 inches)
Lent by the artist
Courtesy Gallery Nature Morte, New York

TROY BRAUNTUCH

Untitled, 1986
pastel on linen
96 x 84 inches
Lent by Paul and Camille Oliver-Hoffmann,
Chicago

**Untitled*, 1986
pastel, ink on linen
108 x 108 inches
Lent by the artist
Courtesy Asher/Faure Gallery, Los Angeles

BETH BRENNER

Weekends Only, 1987
acrylic, artificial snow on canvas and
aluminum cots
73 x 54 x 27 inches
Lent by the artist
Courtesy Annina Nosei Gallery, New York

True Grit, 1987
acrylic, artificial snow on canvas
50 x 66 x 3 inches
Lent by Adam Baumgold, New York

DAVID CABRERA

Polystripe #4, 1986
polyester on birch
61 x 33 inches
Lent by the artist
Courtesy 303 Gallery, New York

Polystripe #1, 1986
polyester on birch
61 x 33 inches
Lent by the artist
Courtesy 303 Gallery, New York

**Polystripe #2*, 1986
polyester on birch
61 x 33 inches
Lent by the artist
Courtesy 303 Gallery, New York

**Polystripe #7*, 1986
polyester on birch
61 x 33 inches
Private collection
Courtesy 303 Gallery, New York

**Polystripe #10*, 1986
polyester on birch
61 x 33 inches
Lent by the artist
Courtesy 303 Gallery, New York

Cut Wood #3, 1987
enamel on mahogany
Four panels, approximately 16 x 12 inches each
Lent by the artist
Courtesy 303 Gallery, New York

JAMES CASEBERE

Covered Wagons, 1986
light box
55 1/2 x 45 1/2 x 10 1/2 inches
Lent by the artist
Courtesy Michael Klein, Inc., New York

DAVID CHOW

I Can Only Tell Him I Am Hungry, 1987
oil on canvas
84 x 72 inches
Lent by the artist, Brooklyn, New York

DORIT CYPIS

Recollection, 1987
From a series of nine "Recollections"
Cibachrome, wood, plexiglass, sheer fabric
38 x 40 x 6 inches
Lent by the artist, Minneapolis, Minnesota

Recollection, 1987
From a series of nine "Recollections"
Cibachrome, wood, plexiglass, sheer fabric
38 x 40 x 6 inches
Lent by the artist, Minneapolis, Minnesota

Recollection, 1987
From a series of nine "Recollections"
Cibachrome, wood, plexiglass, sheer fabric
38 x 40 x 6 inches
Lent by the artist, Minneapolis, Minnesota

DANA DUFF

Shown at The Renaissance Society:
Background #2, #5, #7, #9, #13, #56, #68, #75, #76, #77, #80, #81, #82, #85, #86, #88, 1985-87
compressed charcoal on paper
Sixteen drawings, each 12 x 16 inches framed
Lent by the artist, New York
Courtesy Piezo Electric Gallery, Venice, California

Shown at the Newport Harbor Art Museum:
Background #2, #5, #9, #13, #15, #16, #19, #31, #32, #33, #36, #40, #43, #50, #55, #56, #63, #66 #67, #71, #75, #78, #81, #85, #87, #88, #89, 1985-87
compressed charcoal on paper ·
Twenty-seven drawings,
each 12 x 16 inches framed
Lent by the artist, New York

Background #7, 1985
compressed charcoal on paper
12 x 16 inches framed
Lent by Penelope Milford, Los Angeles, California

TIM EBNER

Color Cue No. 10, 1987
semigloss waterbase paint on canvas
dimensions variable
Collection Newport Harbor Art Museum,
Newport Beach, California

**Untitled*, 1982
aluminum, resin on canvas
50 x 37 inches
Lent by the artist
Courtesy Wolff Gallery, New York

***Color Cue No. 3*, 1986
semigloss waterbase paint on canvas
dimensions variable
Lent by the Eli Broad Family Foundation,
Los Angeles

KATE ERICSON AND MEL ZIEGLER

**Stones Have Been Known to Move
(Detail:Midwest)*, 1986
marble
dimensions variable
Lent by the artists, New York
Courtesy Loughelton Gallery, New York

***Winter Cellar*, 1986
Canned goods from the Pennsylvania Dutch
country, sandblasted glass.
8 inches x 22 feet x 4 inches
In collaboration with Esther Ziegler;
additional contributions from Claire Drescher,
Ruth Drescher, Asa Sensenig, Anna May Stoufer,
Josephine Wise, Carol Ziegler, and Jesse Ziegler.
Lent by the artists, New York

ERIC FISCHL

Couple of Lookers, 1983
oil on paper
35 x 66 inches
Lent by the artist
Courtesy Mary Boone Gallery, New York

***Haircut*, 1985
oil on linen
104 x 84 inches
Lent by the Eli Broad Family Foundation,
Los Angeles

JOHN FRANKLIN

Fold After Cezanne, 1986
plaster, edition of 2
5 1/4 x 19 x 7 1/2 inches
Lent by the artist
Courtesy Loughelton Gallery, New York

Mandorla, 1986
spandex over steel, brass, shellac, rope
14 1/4 x 28 1/2 x 14 1/4 inches
Lent by the artist
Courtesy Loughelton Gallery, New York

JILL GIEGERICH

***Untitled*, 1986
vinyl, copper, ink print collage on paper,
mounted on wood
106 x 73 x 4 inches
Collection Newport Harbor Art Museum,
Newport Beach, California; purchased with
funds provided by the Awards in the Visual Arts
(a program sponsored by the Equitable Founda-
tion and the Rockefeller Foundation) and by the
Acquisition Committee.

***Untitled*, 1986
beeswax, acrylic, paint stick, charcoal, graphite,
india ink on plywood
78 1/4 x 48 inches
Lent by the Edward R. Broida Trust, Los Angeles

JACK GOLDSTEIN

Untitled, 1987
acrylic on canvas
84 x 84 x 6 inches
Lent by Robert and Michele Newcomer, Chicago
Courtesy Dart Gallery, Chicago

***Untitled*, 1987
acrylic on canvas
72 x 96 x 6 inches
Lent by the artist
Courtesy Dart Gallery, Chicago

FARIBA HAJAMADI

**The Reverberation of the Seen and Said,
The Redemption of the Seen and Said*, 1987
oil, emulsion on canvas
Two panels, 48 x 38 inches each
Lent by Colombe and Leonard Rosenberg,
New York
Courtesy Christine Burgin Gallery, New York

***The Telescope With Its Lenses Had Swallowed
The Stars*, 1987
oil, emulsion on canvas
78 x 40 inches
Lent by Randolpho Rocha, Boston
Courtesy Asher/Faure Gallery, Los Angeles

***Between A Thought and A Thing*, 1987
oil, emulsion on canvas
78 x 40 inches
Lent by Christian Leigh, New York
Courtesy Asher/Faure Gallery, Los Angeles

JIM ISERMANN

**Flower Seating Arrangement*, 1985
enamel paint on wood, nylon webbing
28 1/2 x 108 x 108 inches
Lent by the artist
Courtesy Kuhlenschmidt/Simon Gallery,
Los Angeles

**Flower Painting*, 1985
enamel paint on wood
48 x 48 inches
Lent by the artist
Courtesy Kuhlenschmidt/Simon Gallery,
Los Angeles

**Flower Painting*, 1985
enamel paint on wood
48 x 48 inches
Lent by the artist
Courtesy Kuhlenschmidt/Simon Gallery,
Los Angeles

**Flower Painting*, 1985
enamel paint on wood
48 x 48 inches
Lent by the artist
Courtesy Kuhlenschmidt/Simon Gallery,
Los Angeles

**Flower Painting*, 1985
enamel paint on wood
48 x 48 inches
Lent by Nancy Dwyer, New York

**Flower Painting*, 1985
enamel paint on wood
48 x 48 inches
Lent by the artist
Courtesy Kuhlenschmidt/Simon Gallery,
Los Angeles

***Untitled*, 1987
enamel paint on wood
48 x 48 x 2 inches
Lent by the artist
Courtesy Kuhlenschmidt/Simon Gallery,
Los Angeles

***Untitled*, 1987
enamel paint on wood
48 x 48 x 2 inches
Lent by the artist
Courtesy Kuhlenschmidt/Simon Gallery,
Los Angeles

***Untitled*, 1987
enamel paint on wood
48 x 48 x 2 inches
Lent by the artist
Courtesy Kuhlenschmidt/Simon Gallery,
Los Angeles

***Untitled*, 1987
enamel paint on wood
48 x 48 x 2 inches
Lent by the artist
Courtesy Kuhlenschmidt/Simon Gallery,
Los Angeles

LARRY JOHNSON

Untitled (Fuck Suck Cock), 1984
Ektacolor contact prints
28 x 48 inches
Lent by George Waterman III, New York
Courtesy 303 Gallery, New York

Six Movie Stars, 1984
Ektacolor contact prints
Six prints, 8 x 10 inches each
Lent by James Welling, New York

Untitled (Grief is Devastating), 1985
Ektacolor contact prints
Two prints, left 21 1/2 x 25 1/2 inches,
right 25 1/2 x 21 1/2 inches
Courtesy 303 Gallery, New York

**Untitled (Grand Drama)*, 1986
Ektacolor contact prints
Three prints, 18 1/2 x 18 1/2 inches each
Courtesy Kuhlenschmidt/Simon Gallery,
Los Angeles

MIKE KELLEY

Filth I, II, III, 1986
acrylic on paper
Three panels, 60 x 48 inches each
Lent by the artist
Courtesy Metro Pictures, New York, and
Rosamund Felsen Gallery, Los Angeles

Trickle Down, 1986 and *Swaddling Clothes*, 1986
acrylic on paper
Two panels, 60 x 96 inches each
Lent by the artist
Courtesy Metro Pictures, New York, and
Rosamund Felsen Gallery, Los Angeles

JULIA KIDD

**The Desire and the Doll*, 1984
photograph, oil on masonite
60 x 96 x 3 inches
Lent by the artist, New York

**Black and White and Red All Over*, 1986
photograph and oil on masonite
48 x 149 inches x 4 inches
Lent by the artist, New York

JONATHAN LASKER

The Age of Plastic, 1985
oil on canvas
24 x 30 inches
Lent by M. Sawon and T. Banovich, New York

Theoretical Linoleum, 1985
oil on canvas
24 x 30 inches
Lent by Donna J. Jackson, New York
Courtesy Massimo Audiello Gallery, New York

JOHN MILLER

First Place, 1986
gold leaf on hydrocal
11 x 4 x 4 inches
Lent by the artist
Courtesy Metro Pictures, New York

Brown Eye, 1986
acrylic on canvas on wood
16 inches in diameter
Lent by the artist
Courtesy Metro Pictures, New York

I Read A Book, 1987
acrylic on canvas
17 x 25 inches
Lent by Bill Komoski
Courtesy Metro Pictures, New York

Feet of Clay, 1987
wood, porcelain, acrylic
Two parts, 55 x 4 x 4 inches; 59 x 4 x 4 inches
Lent by the artist
Courtesy Metro Pictures, New York

ANDY MOSES

**Night Fall, March 4, 1987*, 1987
acrylic, alkyd on canvas
60 x 90 inches
Lent by the artist
Courtesy Annina Nosei Gallery, New York

**Day Break, April 11, 4721 B.C.*, 1987
acrylic, alkyd on canvas
60 x 90 inches
Lent by the artist
Courtesy Annina Nosei Gallery, New York

**Confessions of Finitude (black)*, 1987
acrylic, alkyd on canvas
67 1/2 x 90 inches
Lent by Bernard and Rosalie Kornblau,
San Marino, California
Courtesy Asher/Faure Gallery, Los Angeles

**A History of Building (white)*, 1987
acrylic, alkyd on canvas
67 1/2 x 90 inches
Lent by Ed Moses, Venice, California
Courtesy Asher/Faure Gallery, Los Angeles

MATT MULLICAN

**Untitled*, 1982
cotton banner
98 x 98 inches
Lent by the artist
Courtesy Michael Klein, Inc., New York

**Untitled (History Over Opera House,
Surrounded by Signs)*, 1986-87
oil stick, acrylic on canvas
192 x 192 inches
Lent by Mr. and Mrs. Robert A. Rowan,
Los Angeles

MARC PALLY

**Milestone*, 1986
oil, oil stick, graphite, colored pencil, oil medium
on paper
57 x 60 1/2 inches
Lent by Gary and Linda Briskman, Beverly Hills,
California

**Pope's Progress*, 1987
oil, oil stick, ink, silkscreen ink, graphite, shellac
on kraft paper
89 x 48 inches
Lent by David Vena and Carol Vena-Mondt,
Los Angeles, California

LARI PITTMAN

**Hibernating*, 1982
oil, acrylic, gold leaf, cork on mahogany
68 x 54 inches
Lent by the artist
Courtesy Rosamund Felsen Gallery, Los Angeles

**The New Republic*, 1985
acrylic, oil on panel
80 x 82 inches
Collection Newport Harbor Art Museum,
Newport Beach, California

**Reason to Rebuild*, 1986
oil, acrylic on wood
82 x 80 inches
Lent by Douglas Cramer, Los Angeles

STEPHEN PRINA

**A Structural Analysis and Reconstruction of
MS7098 as Determined by the Difference
Between the Measurements of Duration and
Displacement, 1980-84/An Evening of 19th- and
20th-Century Piano Music, 1985/TV Guides, 1986*,
1986 (details)
phonograph record, photograph, poster, merchan-
dising display, advertisement, rag mat, American
walnut frame, catalogue entry; arrangement for
piano, piano concert, program, photograph,
poster, announcement, advertisement, rag mat,
American walnut frame, catalogue entry; *TV
Guides*, photograph, merchandising display,
advertisement, public readings, rag mat, American
walnut frame, catalogue entry
Details exhibited: photograph, rag mat, American
walnut frame:
45 1/2 x 35 1/2 inches framed
25 x 21 inches framed
16 x 14 1/4 inches framed
Lent by the artist, Los Angeles

**The No. 1 Single From Billboard's Hot 100 Singles
Chart for the Week Ending January 23, 1988/
(Aristotle—Plato—Socrates, 1982)*, 1988
ink on paper, audio tape, audio equipment
Nine framed drawings, ranging from 9⁵/₁₆ x 6¹¹/₁₆
inches to 51 x 77¼ inches.
Lent by the artist, Los Angeles, California

TOM RADLOFF

#1, 1986
waterbase paint, plaster, paper, wood
32 x 48 inches
Lent by Victoria Lusk, New York
Courtesy Loughelton Gallery, New York

#4, 1986
waterbase paint, plaster, paper, wood
48 x 32 inches
Lent by the artist
Courtesy Loughelton Gallery, New York

#1, 1987
waterbase paint, plaster, paper, wood
31 x 39 1/2 inches
Lent by the artist
Courtesy Loughelton Gallery, New York

DAVID SALLE

Sexual and Professional Jealousy, 1983
oil on canvas
108 x 90 inches
Lent by Gerald Elliott, Chicago

**The Loneliness of Clothes*, 1986
acrylic on canvas with two light bulbs
108 x 90 inches
Eli and Edythe L. Broad Collection, Los Angeles

JIM SHAW

Jesus' Life as a Boy, 1986
xerox on rag paper
17 x 14 inches
Lent by the artist, Los Angeles

Study for Mound of Skulls, 1986
graphite on paper
17 x 14 inches
Lent by the artist, Los Angeles

My Mirage #5, Blood of God, 1986
gouache on plaster
17½ x 14 inches
Lent by the artist, Los Angeles

Food for Thought, 1986
ink on duotone board
17 x 14 inches
Lent by the artist, Los Angeles

Frontispiece, Chapter Two, 1986
gouache on rag paper
17 x 14 inches
Lent by the artist, Los Angeles

*Sometimes He Found Disturbing
Things on the Street*, 1986
graphite on paper
17 x 14 inches
Lent by the artist, Los Angeles

Billy and Susie Go to A Party, 1986
xerox, watercolor on rag paper
17 x 14 inches
Lent by the artist, Los Angeles

Stained Glass, 1986
cel vinyl on colored glass
17 x 14 inches
Lent by the artist, Los Angeles

The Adam and Eve Show, 1986
ink on duotone board
17 x 14 inches
Lent by the artist, Los Angeles

Frontispiece, Chapter One, 1986
gouache on rag paper
17 x 14 inches
Lent by the artist, Los Angeles

**Frontispiece, Chapter Three*, 1987
gouache on paper
17 x 14 inches
Lent by the artist, Los Angeles

**Girls in Billy's Class #4*, 1987
pencil on paper
17 x 14 inches
Lent by the artist, Los Angeles

SUSAN SILAS

Untitled, 1986-87
New York Times Magazine page, red plexiglass
and oil on canvas
Two panels: left 16¼ x 14 inches, right 52 x 40
inches
Lent by the artist, Brooklyn, New York

Realism, 1987
catalogue pages
20¾ x 32¾ inches
Lent by the artist, Brooklyn, New York

MARK STAHL

**The Wet Look*, 1987
fiberglass boulder, raincoat, coathook,
lacquer paint
96 x 48 x 18 inches
Lent by Adam Baumgold, New York
Courtesy Massimo Audiello Gallery, New York

**From Public to Private: 1987*, 1988
fiberglass rocks and boulders, photomural printed
on silver resin paper mounted on masonite,
bathroom accessories, towels, bathrobes
144 x 192 x 196 inches overall
Lent by the artist
Courtesy Massimo Audiello Gallery, New York

MITCHELL SYROP

In the Can, 1986
air conditioner, shower door, black and white
photographs
installation variable; photograph 40 x 26 inches
to 40 x 40 inches
Lent by the artist, Los Angeles
Courtesy Kuhlenschmidt/Simon Gallery,
Los Angeles

A Plied Art, 1988
plastic decals
Lent by the artist, Los Angeles
Courtesy Kuhlenschmidt/Simon Gallery,
Los Angeles

The Gift That Keeps On Giving, 1986
oil on canvas
120 x 76 inches
Collection Newport Harbor Art Museum,
Newport Beach, California

JAMES WELLING

Untitled, 1982/86
C-prints
Three photographs, 19¾ x 23¾ inches each
Lent by the artist
Courtesy Christine Burgin Gallery, New York

Coburg Set, 1984
black and white photographs
Four photographs, 15¼ x 19¼ inches each
Lent by the artist
Courtesy Jay Gorney Modern Art, New York

Untitled (17) 1986, 1986
oil on canvas
26 x 26 inches
Lent by Tim Ebner, Los Angeles

**Untitled (69)*, 1987
vinyl acrylic on canvas
52 x 52 inches
Lent by the artist
Courtesy Kuhlenschmidt/Simon Gallery,
Los Angeles

CHRISTOPHER WILLIAMS

**Pre-Production Advertisement for a Room by
Susanne Ghez and Stephen Prina on the Occasion
of "CalArts: Skeptical Belief(s)" at The Renaissance
Society at the University of Chicago, 1987*, 1987
web offset printing on machine coated paper
15 x 11½ inches image size, 22¼ x 29¼ inches
framed
Lent by the artist, Los Angeles

**Pre-Production Advertisement for A Room by
Susanne Ghez, Paul Schimmel, and Brian Gray on
the Occasion of "CalArts: Skeptical Belief(s)" at the
Newport Harbor Art Museum, Newport Beach,
California, 1988*, 1988
web offset printing on machine coated paper
15 x 11½ inches image size, 22¼ x 29¼ inches
framed
Lent by the artist, Los Angeles

B. WURTZ

Untitled (Stainless Steel Bowl), 1986
mixed-media installation
Two parts: sculpture 9½ x 7½ inches,
photograph 19¾ x 24½ inches
Lent by the artist
Courtesy Feature, Chicago

Untitled (Vase and Portraits), 1986
mixed-media installation
Three parts: sculpture 18½ x 9 x 9 inches,
two paintings 30 x 30 inches each
Lent by the artist
Courtesy Feature, Chicago

FILM AND VIDEO

ERICKA BECKMAN

Cinderella, 1986
24 minutes

DAVID CABRERA

*Will You Please Read Me That Text Again OK Listen
Closely*, 1982
7 minutes

KIRBY DICK

Men Who Are Men, 1981
approximately 30 minutes

SHARON GREYTAK

Wierded Out and Blown Away, 1986
approximately 30 minutes

LINDA TADIC

Une visite à Leon Trotsky, par André Breton, 1986.
30 minutes

LINDA WISSMATH

The Passion of Joan, 1983-86
15 minutes

ASHLEY BICKERTON AND
ANDY MOSES

The Love Story of Pythagoras Redhill, 1981
21 minutes

BARBARA BLOOM

The Diamond Lane, 1981
5:39 minutes

JOHN CALDWELL

The Coming Wound, 1985
18 minutes

BEN CHASE

Crack Down, 1980
5 minutes

How Many Elephants Does It Take?, 1984
1 minute

KEN FEINGOLD

Irony, 1985
29 minutes

FARIBA HAJAMADI AND ANDY MOSES

Excerpts from "The Republic", 1982
5 minutes

KIM INGRAHAM

Corny Stories, 1987
25 minutes

COREY KAPLAN

The Monster Frankenstein, 1984
15 minutes

MIKE KELLEY

The Banana Man, 1983
approximately 25 minutes

JEFF KESSINGER

Let Me Assure You, 1986
7:15 minutes

BIOGRAPHIES

Degrees obtained at other institutions are not listed.

SHERRY MILLNER

Womb With a View, 1983
40 minutes

TONY OURSLER

Evol, 1985
28 minutes

SUSAN PEEHL

You Talkin' To Me?, 1984
28 minutes

JIM SHAW

The Andersons, 1986
2:30 minutes

MITCHELL SYROP

Watch It. Think It., 1977
1 minute

REA TAJIRI

Vertigo (3 Character Descriptions), 1987
10 minutes

MARY ANN TOMAN

There Is My Mother, 1986
7:30 minutes

BRUCE AND NORMAN YONEMOTO WITH MIKE KELLEY

Kappa, 1986
25:58 minutes

CARL AFFARIAN

1980 MFA, CalArts

Selected Exhibitions

1987 Solo exhibition, Lawrence Oliver Gallery, Philadelphia, Pennsylvania
Solo exhibition, Galerie Maeght, Paris, France
Solo exhibition, Van Straaten Gallery, Chicago, Illinois
1986 Solo exhibition, Van Straaten Gallery, Chicago, Illinois
Solo exhibition, Lawrence Oliver Gallery, Philadelphia, Pennsylvania
Adrien Maeght, Paris, France
Lawrence Oliver Gallery, Philadelphia, Pennsylvania
1985 Solo exhibition, Van Straaten Gallery, Chicago Illinois
Solo exhibition, Germans van Eck Gallery, New York, New York
Garbage: L'Uso estetico-artistico del rifiuto urbano, Reggio e Millia, Italy

GARY BACHMAN

1983 MFA, CalArts

Selected Exhibitions

1987 *Nothing Sacred*, Margo Leavin Gallery, Los Angeles, California
1986 Solo exhibition, 303 Gallery, New York, New York
Poetic Resemblance, Hallwalls, Buffalo, New York; traveled to Loughelton Gallery, New York, New York
303 Gallery, New York, New York
Greenberg's Dilemma, Loughelton Gallery, New York, New York

DENNIS BALK

1984 MFA, CalArts

Selected Exhibitions

1987 *Fake*, The New Museum of Contemporary Art, New York, New York
Projections in Public, Los Angeles and San Diego, sponsored by Foundation for Art Resources and Los Angeles Institute of Contemporary Art
1986 *Hang Twelve*, Piezo Electric Gallery, Venice, California
TV Generations, Los Angeles Contemporary Exhibitions, Los Angeles, California
1985 *Proof and Perjury*, Los Angeles Institute of Contemporary Art, Los Angeles, California

ERICKA BECKMAN

1976 MFA, CalArts

Selected Exhibitions and Screenings

1987 Milwaukee Art Museum, Milwaukee, Wisconsin
Biennial Exhibition, Whitney Museum of American Art, New York, New York
Re-Vision Festival, Brattle Theater, Boston, Massachusetts
The Hirshhorn Museum and Sculpture Garden, Smithsonian Institution, Washington, D.C.
San Francisco Cinematheque, San Francisco, California
International Theatre Festival, Valladolid, Spain

1986 The Kitchen, New York, New York
Au Coeur du Maelstrom, Palais des Beaux Arts, Brussels, Belgium
The Walker Art Center, Minneapolis, Minnesota
1985 *Biennial Exhibition*, Whitney Museum of American Art, New York, New York

CINDY BERNARD

1985 MFA, CalArts

Selected Exhibitions

1987 *Spiral of Artificiality*, Hallwalls, Buffalo, New York
Breaking Through the Looking Glass...East, Holly Solomon Gallery, New York, New York
Breaking Through the Looking Glass...West, Fahey Klein Gallery, Los Angeles, California
Room 9, Tropicana Motel, Los Angeles, California
1986 *TV Generations*, Los Angeles Contemporary Exhibitions, Los Angeles, California

ASHLEY BICKERTON

1982 BFA, CalArts

Selected Exhibitions

1987 Solo exhibition, International with Monument, New York, New York
Solo exhibition, Donald Young Gallery, Chicago, Illinois
New York New, Paul Maenz, Cologne, West Germany
1986 Solo exhibition, Cable Gallery, New York, New York
Art and Its Double, Barcelona and Madrid, Spain
Sonnabend Gallery, New York, New York
Prospekt 86, Frankfurt Kunstverein, Frankfurt, West Germany
Signs of Painting, Donald Young Gallery, Chicago, Illinois; Metro Pictures, New York, New York
1984 Solo exhibition, Artists Space, New York, New York
1979 Solo exhibition, CalArts

ROSS BLECKNER

1973 MFA, CalArts

Selected Exhibitions

1987 Solo exhibition, Margo Leavin Gallery, Los Angeles, California
Solo exhibition, Mary Boone Gallery, New York, New York

The Antique Future, Massimo Audiello Gallery, New York, New York
Biennial Exhibition, Whitney Museum of American Art, New York, New York
Post-Abstract Abstraction, The Aldrich Museum of Contemporary Art, Ridgefield, Connecticut
1986 Solo exhibition, Mary Boone Gallery, New York, New York
End Game: Reference and Simulation in Recent American Painting and Sculpture, Institute of Contemporary Art, Boston, Massachusetts
1985 *Vernacular Abstraction*, Wacoal Art Center, Tokyo, Japan
1984 Solo exhibition, Gallery Nature Morte, New York, New York
1975 *Biennial Exhibition*, Whitney Museum of American Art, New York, New York

BARBARA BLOOM

1972 BFA, CalArts

Selected Exhibitions and Screenings

1987 Haags Gemeentemuseum, The Hague,
The Netherlands
Solo exhibition, Daadgalerie, Berlin,
West Germany
Solo exhibition, Nature Morte, New York,
New York
1986 *Damaged Goods*, The New Museum of
Contemporary Art, New York, New York
1985 *Wat Amsterdam Bereft*, Stedelijk Museum,
Amsterdam, The Netherlands
Alles en Nog Viel Nehr, Kunstmuseum,
Bern, Switzerland
Display Systems, Foundation de Appel,
Amsterdam, The Netherlands
1982 *Extended Photography*, Secession, Vienna
1981 *Westkunst: Heute*, Cologne, West Germany
1980 Solo exhibition, Musuem Boymans van
Beuningen, Rotterdam, The Netherlands

TROY BRAUNTUCH

1975 BFA, CalArts

Selected Exhibitions

1986 Solo exhibition, Larry Gagosian Gallery,
Los Angeles, California
1985 Solo exhibition, Mary Boone Gallery,
New York, New York
1984 Solo exhibition, Akira Ueda Gallery,
Tokyo, Japan
*An International Survey of Contemporary
Painting and Sculpture*, The Museum of
Modern Art, New York, New York
1983 Solo exhibition, Galerie Schellman and
Kluser, Munich, West Germany
1982 Solo exhibition, Mary Boone Gallery,
New York, New York
Documenta, Kassel, West Germany
La Biennale di Venezia, Venice, Italy
1981 Solo exhibition, Metro Pictures, New York,
New York
1979 Solo exhibition, The Kitchen, New York,
New York

BETH BRENNER

1983 MFA, CalArts

Selected Exhibitions

1987 Annina Nosei Gallery, New York, New York
Nuovi Territori dell'Arte, Europa/America,
Fondazione Michetti, Francavilla al Mare,
Italy
The Art of the Real, Galerie Pierre Huber,
Geneva, Switzerland
Spatial-FX, Annina Nosei Gallery, New York,
New York
Grand Design, Bard College,
Annandale-on-Hudson, New York
Reconstruct, John Gibson Gallery,
New York, New York
Perverted by Language, Hillwood Art
Gallery, Long Island University, New York
303 Gallery, New York, New York
American Fine Arts, New York, New York
Mind/Matter, Bess Cutler Gallery,
New York, New York

DAVID CABRERA

1982 MFA, CalArts
1979 BFA, CalArts

Selected Exhibitions and Screenings

1987 Solo exhibition, 303 Gallery, New York,
New York
Nuovi Territori dell'Arte, Europa/America,
Fondazione Michetti, Francavilla al Mare,
Italy
Fake, The New Museum of Contemporary
Art, New York, New York
1986 Solo exhibition, 303 Gallery, New York,
New York
Solo exhibition, Hallwalls, Buffalo,
New York
Altered States, Bard College,
Annandale-on-Hudson, New York
Spiritual America, CEPA, Buffalo, New York
1984 *Independent Cinema 1*, St. Marks Cinema,
New York, New York
1983 *Experimentelle Kurzfilme aus den USA*,
Dusseldorf, Duisberg, and Dortmund, West
Germany; Zurich and Aarau, Switzerland
1982 *A Likely Story*, Artists Space, New York,
New York

JOHN CALDWELL

1978 MFA, CalArts

Selected Exhibitions and Screenings

1986 *New Documentary Forms*, The Kitchen,
New York, New York
1985 *Sightworks Series*, Millennium Film
Workshop, New York, New York
1983 *Two New Documentaries*, The Center for
New Television, Chicago, Illinois
Headhunters, Los Angeles Contemporary
Exhibitions, Los Angeles, California
Pax-Americanus, WNED-TV (PBS), Buffalo,
New York
1980 *California Video*, Musée d'Art Moderne,
Paris, France
Artist Showcase, WGBH-TV (PBS),
Boston, Massachusetts
1979 *Southern California Video*, Media Study,
Buffalo, New York
New Video, Long Beach Museum of Art,
Long Beach, California
Image Union, WTTV-TV (PBS),
Chicago, Illinois

JAMES CASEBERE

1979 MFA, CalArts

Selected Exhibitions

1987 Solo exhibition, 303 Gallery, New York,
New York
Solo exhibition, Michael Klein, Inc.,
New York, New York
Solo exhibition, Kuhlenschmidt/Simon
Gallery, Los Angeles, California
*This Is Not A Photograph: Twenty Years of
Large Scale Photography, 1966-1986*, The
John and Mable Ringling Museum of Art,
Sarasota, Florida; traveled.
*Photography and Art: Interactions Since
1946*, Los Angeles County Museum of Art,
Los Angeles, California
*Cross References: Sculpture into
Photography*, Walker Art Center,
Minneapolis, Minnesota
1985 Solo exhibition, Kuhlenschmidt/Simon
Gallery, Los Angeles, California
Solo exhibition, Minneapolis College of Art
and Design, Minneapolis, Minnesota

1984 Solo exhibition, Diane Brown Gallery,
New York, New York
Solo exhibition, Sonnabend Gallery,
New York, New York

BEN CHASE

1981 MFA, CalArts

Selected Exhibitions and Screenings

1987 *The New Who's Who*, HoffmanBorman
Gallery, Los Angeles, California
1986 303 Gallery, New York, New York
4 x 4—Artists Pick Artists Show, Jus de
Pomme Gallery, New York, New York
1985 Anthology Film Archives, New York,
New York
TV Works, Los Angeles Institute of
Contemporary Art, Los Angeles, California
1984 *Sign on a Truck*, New York, New York
Werkstatt fur Fotografie, VHS Kreuzberg,
Berlin, West Germany
*Tyler Alumni Invitational/Fiftieth
Anniversary*, Philadelphia, Pennsylvania
Kunst und Massenmedien, Vienna, Austria
West Coasters, Hara Museum and
Image/Form, Tokyo, Japan

DAVID CHOW

1980 MFA, CalArts
1975 BFA, CalArts

Selected Exhibitions

1984 *Eccentric Images*, Margo Leavin Gallery,
Los Angeles, California
1980 Solo exhibition, CalArts
1979 University of California, Berkeley, California
1978 Solo exhibition, CalArts
Claremont College, Claremont, California
University of California, Irvine, California

DORIT CYPIS

1977 MFA, CalArts

Selected Exhibitions

1987 *Heavenly Embrace*, Baskerville + Watson
Gallery, New York, New York
Sexual Difference: Both Sides of the Camera,
traveled
1986 *Three Photographers: The Body*, The New
Museum of Contemporary Art, New York,
New York
Love After Death: A Renaissance, produced
by UC Video, Minneapolis, Minnesota
Love After Death, Palais des Beaux Arts,
Brussels, Belgium
Incantation, Faulkirk Victorian Cultural
Center, San Rafael, California
*Body Talk: The Panorama Story, The Real Big
Picture Exhibition*, Queens Museum,
Flushing, New York
The Artist and Her Model, De Zaak,
Groningen, The Netherlands
1985 *Vanity: Just a Split Second Away, Talking
Back to the Media*, Amsterdam,
The Netherlands

KIRBY DICK

1985 CalArts

Selected Film Screenings

1987 Cable broadcast, Cinemax, HBO
1986 Cable broadcast, Playboy Channel
Margaret Mead Film Festival, New York,
New York
1985 USA Film Festival
Atlanta Film and Video Festival,
Atlanta, Georgia
Montreal World Film Festival, Montreal,
Quebec, Canada
Filmex
1981 Bleecker Street Cinema, New York,
New York
Artists Space, New York, New York
Long Beach Museum of Art,
Long Beach, California

DANA DUFF

1981 MFA, CalArts

Selected Exhibitions

1987 Solo exhibition, Piezo Electric Gallery,
Venice, California
Breaking Through the Looking Glass…East,
Holly Solomon Gallery, New York,
New York
Works on Paper, Pence Gallery, Los Angeles,
California
Fresno Art Center and Museum, Fresno,
California
LA2DA, La Jolla Museum of Contemporary
Art, La Jolla, California
1986 *Fabricated, Not Found*, Loughelton Gallery,
New York, New York
Hang Twelve, Piezo Electric Gallery,
Venice, California
1985 *B & W*, Los Angeles Institute of
Contemporary Art, Los Angeles, California
LACE Salutes Pershing Square,
Los Angeles Contemporary Exhibitions,
Los Angeles, California

TIM EBNER

1982 MFA, CalArts
1979 BFA, CalArts

Selected Exhibitions

1987 *Nuovi Territori dell'Arte, Europa/America*,
Fondazione Michetti, Francavilla al Mare,
Italy
Fake, The New Museum of Contemporary
Art, New York, New York
Bard College, Annandale-on-Hudson,
New York
New Locations, Wolff Gallery, New York,
New York
Robbin Lockett Gallery, Chicago, Illinois
1986 Solo exhibition, Kuhlenschmidt/Simon
Gallery, Los Angeles, California
Solo exhibition, Wolff Gallery, New York,
New York
1985 *Breakfast at Vickman's*, Vickman's
Restaurant, Los Angeles, California
Los Angeles Institute of Contemporary Art,
Los Angeles, California
1982 Solo exhibition, Los Angeles Contemporary
Exhibitions, Los Angeles, California

KATE ERICSON

1982 MFA, CalArts

Selected Exhibitions and Public Projects

1987 *Real Pictures*, Wolff Gallery, New York,
New York
Nature, Feature, Chicago, Illinois
Time The Destroyer Is Time The Preserver,
Loughelton Gallery, New York, New York
1986 *Stones Have Been Known To Move*, White
Columns, New York, New York
*If You Would See the Monument, Look
Around*, Central Park, New York, New York.
Sponsored by Creative Time, Inc., and
Central Park's Summer Stage in
collaboration with the New York City
Department of Parks and Recreation and
Central Park Conservancy.
House Monument, Los Angeles Institute of
Contemporary Art, Los Angeles, California
1985 *Garden Sculpture*, Ward's Island, New York,
New York. Organized by A.R.E.A.
1984 *Selections from the Artists File*, Artists Space,
New York, New York
Art on the Beach, New York, New York.
Organized by Creative Time
1983 Window Installation, The New Museum of
Contemporary Art, New York, New York

KEN FEINGOLD

1976 MFA, CalArts
1974 BFA, CalArts

Selected Exhibitions and Screenings

1987 Centre Georges Pompidou, Paris, France
World Wide Video Festival, The Hague,
The Netherlands
1986 The Kitchen, New York, New York
1985 The Museum of Modern Art, New York,
New York
Biennial Exhibition, Whitney Museum of
American Art, New York, New York
WGBH-TV (PBS), Boston, Massachusetts
The New Museum of Contemporary Art,
New York, New York
The American Center, Paris, France
1984 *Berlin Film Festival*, Berlin, West Germany
1979 Solo exhibition, Whitney Museum of
American Art, New York, New York

ERIC FISCHL

1972 BFA, CalArts

Selected Exhibitions

1987 Solo exhibition, Mary Boone Gallery,
New York, New York
Documenta 8, Kassel, West Germany
1986 Solo exhibition, The Whitney Museum of
American Art, New York, New York
*Individuals: A Selected History of
Contemporary Art*, Museum of
Contemporary Art, Los Angeles, California
1985 Solo exhibition, Institute of Contemporary
Arts, London, England
Solo exhibition, Kunsthalle Basel, Basel,
Switzerland
Solo exhibition, Stedelijk Van
Abbemuseum, Eindhoven, The Netherlands

Biennial Exhibition, Whitney Museum of
American Art, New York, New York
Carnegie International, Museum of Art,
Carnegie Institute, Pittsburgh, Pennsylvania
1983 *Biennial Exhibition*, Whitney Museum of
American Art, New York, New York

JOHN FRANKLIN

1984 MFA, CalArts

Selected Exhibitions

1987 Solo exhibition, Loughelton Gallery,
New York, New York
The Glittering Prize, Stux Gallery, New York,
New York
1986 Solo exhibition, White Columns, New York,
New York
Fabricated, Not Found, Loughelton Gallery,
New York, New York
Retroactive, Hallwalls, Buffalo, New York
Update, White Columns, New York,
New York
1984 *Political Art*, CalArts
1982 Solo installation, *Anxiety of Influence*,
CalArts
Solo installation, *Subject to Change*, CalArts

JILL GIEGERICH

1977 MFA, CalArts
1975 BFA, CalArts

Selected Exhibitions

1987 Solo exhibition, Carnegie-Mellon University
Art Gallery, Pittsburgh, Pennsylvania
Solo exhibition, Margo Leavin Gallery,
Los Angeles, Califorina
*Toyama Now '87: New Art Around the
Pacific*, The Museum of Modern Art,
Toyama, Japan
Awards in the Visual Arts 6, Grey Art
Gallery, New York University, New York,
New York; The Contemporary Arts Center,
Cincinnati, Ohio
Newport Biennial, Newport Harbor Art
Museum, Newport Beach, California
1986 Solo exhibition, David McKee Gallery,
New York, New York
1985 Solo exhibition, Museum of Contemporary
Art, Los Angeles, California
Biennial Exhibition, Whitney Museum of
American Art, New York, New York
1983 Solo exhibition, Margo Leavin Gallery,
Los Angeles, California

JACK GOLDSTEIN

1972 MFA, CalArts

Selected Exhibitions

1987 Solo exhibition, John Weber Gallery,
New York, New York
1987 *Aspects l'art d'aujourd'hui: l'epoque, la
mode, la morale, la passion*, Centre Georges
Pompidou, Paris, France
1986 *Prospect '86*, The Museum of Modern Art,
Frankfurt, West Germany
Solo exhibition, Dart Gallery,
Chicago, Illinois
Solo exhibition, Metro Pictures, New York,
New York
1985 *Biennial Exhibition*, Whitney Museum of
American Art, New York, New York
Solo exhibition, Dart Gallery,
Chicago, Illinois
1984 *An International Survey of Recent Painting
and Sculpture*, The Museum of Modern Art,
New York, New York
1983 *New Art*, Tate Gallery, London, England
Back to the USA, Kunstmuseum, Lucerne,
Switzerland; traveled to Rheinsches
Landesmuseum, Bonn, West Germany, and
Wurttembergischer Kunstverein, Stuttgart,
West Germany

SHARON GREYTAK

1982 MFA, CalArts

Selected Screenings

1987 *Filmotsav*, International Film Festival of India and Tour, New Delhi, India
1986 Joseph Papp's Public Theatre, New York, New York
 Independent Focus Series, WNET-TV (PBS), New York, New Jersey, Connecticut
 Margaret Mead Film Festival, New York, New York
1983 Solo exhibition, *Cineprobe*, The Museum of Modern Art, New York, New York

FARIBA HAJAMADI

1982 MFA, CalArts

Selected Exhibitions

1987 Solo exhibition, CEPA Gallery, Buffalo, New York
 Solo exhibition, Christine Burgin Gallery, New York, New York
 Solo exhibition, Queens Museum, Queens, New York
 Solo exhibition, *Investigations*, Institute of Contemporary Art, University of Pennsylvania, Philadelphia, Pennsylvania
 Fake, The New Museum of Contemporary Art, New York, New York
 2001-1/2, Loughelton Gallery, New York, New York
 Galerie Ralph Wernicke, Stuttgart, West Germany
 Asher/Faure Gallery, Los Angeles, California
 Abbaye de Fontevraud, Fontevraud, France
1984 *The New Portrait*, P.S.1, Long Island City, New York

KIM INGRAHAM

1982 MFA, CalArts
1980 BFA, CalArts

Selected Screenings

1987 Film/Video Arts, New York, New York
1986 The Kitchen, New York, New York
 The Women's Building, Los Angeles, California
1985 Hudson Center Gallery, New York, New York
1983 Artists Space, New York, New York
 Foundation for Art Resources, Los Angeles, California
 White Columns (Cable Broadcast), New York, New York
1982 Mark Goodson Theatre, Los Angeles, California
 CalArts

JIM ISERMANN

1980 MFA, CalArts

Selected Exhibitions

1987 *I Bienal Internacional de Pintura*, Museo de Arte Moderno, Cuena, Ecuador
 Avant-Garde in the Eighties, Los Angeles County Museum of Art, Los Angeles, California
1986 Solo exhibition, *Nu-Flowers*, Patty Aande Gallery, San Diego, California
 Solo exhibition, *Flowers*, Kuhlenschmidt/Simon Gallery, Los Angeles, California
 TV Generations, Los Angeles Contemporary Exhibitions, Los Angeles, California

1984 Solo exhibition, *Suburban*, Richard Kuhlenschmidt Gallery, Los Angeles, California
 Furniture, Furnishings: Subject and Object, Museum of Art, Rhode Island School of Design, Providence, Rhode Island
1982 Solo exhibition, *Motel Modern*, The Inn of Tomorrow, Anaheim, California; and Richard Kuhlenschmidt Gallery, Los Angeles, California
 Solo exhibition, *Patio Tempo*, Artists Space, New York, New York

LARRY JOHNSON

1984 MFA CalArts
1982 BFA, CalArts

Selected Exhibitions

1987 Solo exhibition, 303 Gallery, New York, New York
 Solo exhibition, Kuhlenschmidt/Simon Gallery, Los Angeles, California
 Solo exhibition, Isabella Kacprzak, Stuttgart, West Germany
 On View, The New Museum of Contemporary Art, New York, New York
 Galerie Christoph Durr, Munich, West Germany
 The Castle, installation by Group Material, *Dokumenta 8*, Kassel, West Germany
1986 Solo exhibition, 303 Gallery, New York, New York
 Uplifted Atmospheres, Borrowed Taste, Hallwalls, Buffalo, New York
1985 *Synaesthetics*, P.S.1, New York, New York
 Proof and Perjury, Los Angeles Institute of Contemporary Art, Los Angeles, California

COREY KAPLAN

1982 BFA, CalArts

Selected Exhibitions and Screenings

1986 Foundation for Art Resources, Los Angeles, California
1985 *Women Photographers in America*, Los Angeles Photographic Center, Los Angeles, California
 EZTV, Los Angeles, California
 New LA Filmmakers, Artists Space, New York, New York

MIKE KELLEY

1978 MFA, CalArts

Selected Exhibitions

1986 Solo exhibition, Metro Pictures, New York, New York
 Plato's Cave, Rothko's Chapel, Lincoln's Profile (performance), Artists Space, New York, New York
 Individuals: A Selected History of Contemporary Art, 1945-1986, Museum of Contemporary Art, Los Angeles, California
 Avant-Garde in the Eighties, Los Angeles County Museum of Art, Los Angeles, California
1985 Solo exhibition, Rosamund Felsen Gallery, Los Angeles, California
 Monkey Island, Part II (performance), Municipal Art Gallery Theatre, Los Angeles, California
 Biennial Exhibition, Whitney Museum of American Art, New York, New York
1984 *The Fifth Biennale of Sydney, Private Symbol: Social Metaphor*, Art Gallery of New South Wales, Sydney, Australia
1983 Solo exhibition, Hallwalls, Buffalo, New York

JEFF KESSINGER

1986 MFA, CalArts

JULIA KIDD

1984 MFA, CalArts

Selected Exhibitions

1987 *Paint/Film*, Bess Cutler Gallery, New York, New York
 The Double Bind, Loughelton Gallery, New York, New York
 Update 1986-87, White Columns, New York, New York
1986 Solo exhibition, *Great Friends*, White Columns, New York, New York
 The Fairytale, Politics, Desire and Everyday Life, Artists Space, New York, New York
 The Readymade Painted, Bard College, Annandale-on-Hudson, New York
 TV Generation, Los Angeles Contemporary Exhibitions, Los Angeles, California
1984 Solo exhibition, *Party Games*, Los Angeles Institute of Contemporary Art, Los Angeles, California
 Opposing Force, Hallwalls, Buffalo, New York

JONATHAN LASKER

1977 CalArts

Selected Exhibitions

1987 *Biennial Exhibition of Painting*, Corcoran Gallery of Art, Washington, D.C.
 Post-Abstract Abstraction, The Aldrich Museum of Contemporary Art, Ridgefield, Connecticut
1986 Solo exhibition, Michael Werner, Cologne, West Germany
 Solo exhibition, Massimo Audiello Gallery, New York, New York
 Abstraction/Abstraction, Carnegie-Mellon University Art Gallery, Pittsburgh, Pennsylvania; and Klein Gallery, Chicago, Illinois
1985 *Final Love*, Cash/Newhouse Gallery, New York, New York
 Paravision, Postmasters Gallery, New York, New York
 Kolner Herbstalon, Wacoal Art Center, Tokyo, Japan
1984 Solo exhibition, Tibor de Nagy, New York, New York

JOHN MILLER

1979 MFA, CalArts

Selected Exhibitions

1986 Solo exhibition, Metro Pictures, New York, New York
 Signs of Painting, Metro Pictures, New York, New York; traveled to Donald Young Gallery, Chicago, Illinois
1985 Solo exhibition, Rosamund Felsen Gallery, Los Angeles, California
 New York Art Now: Correspondences, La Foret Museum, Tokyo, Japan; traveled.
 Americana, by Group Material in *Biennial Exhibition*, Whitney Museum of Ameican Art, New York, New York
 Smart Art, Carpenter Center for the Visual Arts, Harvard University, Boston, Massachusetts
1984 Solo exhibition, Rosamund Felsen Gallery, Los Angeles, California
 Solo exhibition, Metro Pictures, New York, New York

1983 Solo exhibition, The Kitchen, New York, New York

1982 Solo exhibition, White Columns, New York, New York

SHERRY MILLNER

1976 MFA, CalArts

Selected Exhibitions and Screenings

1987 *Festival International de Films et Videos de Femmes de Montreal*, Quebec, Canada
Biennial Exhibition, Whitney Museum of American Art, New York, New York
Video Discourse: Mediated Narratives, La Jolla Museum of Contemporary Art, La Jolla, California

1986 *The Black Maria Film and Video Festival*, The Thomas A. Edison National Historic Site, West Orange, New Jersey
New California Video, American Museum of the Moving Image, Astoria, New York
Open Channels Video Show, Long Beach Museum of Art, Long Beach, California
American Film Institute National Video Festival, Los Angeles, California

1985 *What Does She Want?*, Artists Space, New York, New York

1984 Solo exhibition, Center for Art Tapes, Halifax, Nova Scotia, Canada
Stories of Her Own, Walker Art Center, Minneapolis, Minnesota

ANDY MOSES

1979-82 CalArts

Selected Exhibitions

1987 *Nuovi Territori dell'Arte, Europa/America*, Fondazione Michetti, Francavilla al Mare, Italy
Solo exhibition, Annina Nosei Gallery, New York, New York
Andy Moses and Tod Wizon, Annina Nosei Gallery, New York, New York
Special FX, Annina Nosei Gallery, New York, New York
Topology, Asher/Faure Gallery, Los Angeles, California

1986 *Selections*, Artists Space, New York, New York
Ex-Photo, DeMille Room, New York, New York

1981 Solo exhibition, CalArts

1980 Solo exhibition, CalArts

1979 Solo exhibition, *Father Knows Best*, CalArts

MATT MULLICAN

1974 BFA, CalArts

Selected Exhibitions

1987 Solo exhibition, Dallas Museum of Art, Dallas, Texas
Solo exhibition, Fuller Goldeen Gallery, San Francisco, California
Solo exhibition, Kuhlenschmidt/Simon Gallery, Los Angeles, California
Solo exhibition, Michael Klein, Inc., New York, New York
Solo exhibition, Moore College of Art, Philadelphia, Pennsylvania
Skulptur Projekte in Munster, 1987, Munster, West Germany
Aspects de l'Art d'Aujourd'hui: l'epoque, la mode, la morale, la passion, Centre Georges Pompidou, Paris, France

1986 Solo exhibition, Everson Museum of Art, Syracuse, New York

1985 Solo exhibition, Kuhlenschmidt/Simon Gallery, Los Angeles, California
Solo exhibition, McIntosh/Drysdale, Washington, D.C.

TONY OURSLER

1979 BFA, CalArts

Selected Exhibitions and Screenings

1987 Solo exhibition, Donnell Film/Library, New York, New York
Spillchamber (installation), Japan 1987 Video Television Festival, Tokyo, Japan

1986 Solo exhibition, Cinematheque, San Francisco, California

1985 Solo exhibition, Schule Fur Gestaltung, Basel, Switzerland
Spheres of Influence (installation), Centre Georges Pompidou, Paris, France; traveled to Haags Gemeentemuseum, The Hague, The Netherlands, and Museum van Hedendaagse Kunst, Gent, Belgium

1984 Solo exhibition, Mo David Gallery, New York, New York
L-7, L-5 (installation), The Kitchen, New York, New York; and Stedelijk Museum, Amsterdam, The Netherlands

1983 Solo exhibition, Los Angeles Contemporary Exhibitions, Los Angeles, California

1982 Solo exhibition, Walker Art Center, Minneapolis, Minnesota

1981 Solo exhibition, The Museum of Modern Art, New York, New York

MARC PALLY

1978 MFA, CalArts

Selected Exhibitions

1988 Solo exhibition, Newport Harbor Art Museum, Newport Beach, California

1987 Solo exhibition, Rosamund Felsen Gallery, Los Angeles, California

1986 Solo exhibition, Rosamund Felsen Gallery, Los Angeles, California
First Annuale, Los Angeles Contemporary Exhibitions, Los Angeles, California

1985 *Drawing Ex Machina*, Fine Arts Gallery, University of California, Irvine, California
Sunshine/Shadows: Recent Painting in Southern California, Fisher Gallery, University of Southern California, Los Angeles, California

1984 Solo exhibition, Ulrike Kantor Gallery, Los Angeles, California
Richard Kuhlenschmidt Gallery, Los Angeles, California

1981 Solo exhibition, Ulrike Kantor Gallery, Los Angeles, California

SUSAN PEEHL

1983 MFA, CalArts

Selected Exhibitions and Screenings

1986 F.A.R., Los Angeles, California

1985 Manhattan Cable, New York, New York
Democracy at Work, 22 Wooster Gallery, New York, New York

1984 *Propaganda*, Franklin Furnace, New York, New York

1983 *Arts and Commerce*, Video Red Bar, New York, New York

LARI PITTMAN

1976 MFA, CalArts

1974 BFA, CalArts

Selected Exhibitions

1987 Solo exhibition, Rosamund Felsen Gallery, Los Angeles, California
Biennial Exhibition, Whitney Museum of American Art, New York, New York
Highlights of California Art Since 1945—A Collecting Partnership, Newport Harbor Art Museum, Newport Beach, California
Western States Biennial, Phoenix Art Museum, Phoenix, Arizona

1986 Solo exhibition, Patty Aande Gallery, San Diego, California

1985 Solo exhibition, Rosamund Felsen Gallery, Los Angeles, California

1984 Solo exhibition, Rosamund Felsen Gallery, Los Angeles, California

1983 Solo exhibition, Rosamund Felsen Gallery, Los Angeles, California
Los Angeles/New York Exchange, Artists Space, New York, New York

1982 Solo exhibition, Newport Harbor Art Museum, Newport Beach, California

STEPHEN PRINA

1980 MFA, CalArts

Selected Exhibitions

1988 *Striking Distance*, Museum of Contemporary Art, Los Angeles, California

1987 *Nothing Sacred*, Margo Leavin Gallery, Los Angeles, California
Tim Ebner, John L. Graham, Stephen Prina, Christopher Williams, Kuhlenschmidt/Simon Gallery, Los Angeles, California

1986 *Rooted Rhetoric, Una Tradizione dell'Arte Americana*, Castel dell'Ovo, Naples, Italy

1985 *Stephen Prina, Mark Stahl, Christopher Williams*, Galerie Crousel-Hussenot, Paris, France
The Art of Memory/The Loss of History, The New Museum of Contemporary Art, New York, New York

1984 *Jenny Holzer, Stephen Prina, Mark Stahl, Christopher Williams*, Foundation de Appel, Amesterdam, The Netherlands, and Gewad, Gent, Belgium

1982 *74th American Exhibition*, The Art Institute of Chicago, Chicago, Illinois

1980 *Investigations: Probe.Structure.Analysis*, The New Museum of Contemporary Art, New York, New York

TOM RADLOFF

1972 MFA, CalArts

Selected Exhibitions

1988 Solo exhibition, Loughelton Gallery, New York, New York

1987 *Apfelbaum, Radloff, Szymanski*, Loughelton Gallery, New York, New York

1986 *Selections*, Artists Space, New York, New York

1976 Solo exhibition, *Variety*, Theater Vanguard, Los Angeles, California
Evening of Works, Los Angeles Institute of Contemporary Art, Los Angeles, California

1975 Long Beach Museum of Art, Los Angeles, California

1973 *Faculty Exhibition*, University of California, Irvine, California

1971 Solo exhibition, CalArts
Videoart, The Pasadena Museum of Art, Pasadena, California

DAVID SALLE

1975 MFA, CalArts
1973 BFA, CalArts

Selected Exhibitions

1987 Solo exhibition, Whitney Museum of
American Art, New York, New York
Solo exhibition, Museum of Contemporary
Art, Los Angeles, California
Solo exhibition, Museum of Contemporary
Art, Chicago, Illinois
Solo exhibition, Mary Boone Gallery,
New York, New York
1986 Solo exhibition, Institute of Contemporary
Art, Boston, Massachusetts
1985 Solo exhibition, Galerie Michael Werner,
Cologne, West Germany
Biennial Exhibition, Whitney Museum of
American Art, New York, New York
Carnegie International, Museum of Art,
Carnegie Institute, Pittsburgh, Pennsylvania
1983 *Biennial Exhibition*, Whitney Museum of
American Art, New York, New York
1982 *Dokumenta 7*, Kassel, West Germany

JIM SHAW

1978 MFA, CalArts

Selected Exhibitions

1987 *Heterodoxy*, Rosamund Felsen Gallery,
Los Angeles, California
LA2DA, La Jolla Museum of Contemporary
Art, La Jolla, California
1986 *TV Generations*, Los Angeles Contemporary
Exhibitions, Los Angeles, California
Social Distortions, Los Angeles Contempo-
rary Exhibitions, Los Angeles, California
Solo exhibition, *Nuclear Family*, EZTV,
Los Angeles, California
Hang Twelve, Piezo Electric Gallery,
Los Angeles, California
1985 *Floor Show*, Los Angeles Contemporary
Exhibitions, Los Angeles, California
Magic Show, Atelier Gallery, University of
Southern California, Los Angeles, California
Black and White, Los Angeles Institute of
Contemporary Art, Los Angeles, California
1981 Solo exhibition, Zero-Zero Club

SUSAN SILAS

1983 MFA, CalArts

Selected Exhibitions

1987 White Columns, New York, New York
Nothing Sacred, Margo Leavin Gallery,
Los Angeles, California
Projections in Public, Los Angeles and
San Diego, California
1986 303 Gallery, New York, New York
Greenberg's Dilemma, Loughelton Gallery,
New York, New York
1984 *Sign on a Truck*, Battery Park, 57th Street
and Fifth Avenue; and The Kitchen,
New York, New York
1980 The Delaware Art Museum,
Wilmington, Delaware

MARK STAHL

1981 MFA, CalArts
1979 BFA, CalArts

Selected Exhibitions

1987 Solo exhibition, Galerie Pierre Huber,
Geneva, Switzerland
Solo exhibition, Massimo Audiello Gallery,
New York, New York
Primary Structures, Rhona Hoffman Gallery,
Chicago, Illinois
Post-Abstract Abstraction, The Aldrich
Museum of Contemporary Art,
Ridgefield, Connecticut
Reconstruct, John Gibson Gallery,
New York, New York
1986 *When Attitudes Become Form*, Bess Cutler
Gallery, New York, New York
1985 *The Public Art Show*, Nexus Contemporary
Art Center, Atlanta, Georgia
Marian Goodman Gallery,
New York, New York
Galerie Crousel-Hussenot, Paris, France
Foundation de Appel,
Amsterdam, The Netherlands

MITCHELL SYROP

1978 MFA, CalArts

Selected Exhibitions and Screenings

1988 Museum of Contemporary Art, Los Angeles
1987 Solo exhibition, Matrix Gallery, University
Art Museum, Berkeley, California
LA Video, KCET-TV, Los Angeles
1986 Solo exhibition, Kuhlenschmidt/Simon
Gallery, Los Angeles, California
1985 *Public Art*, Nexus, Atlanta, Georgia
Blow Up, Feature, Chicago, Illinois
1984 Solo exhibition, Richard Kuhlenschmidt
Gallery, Los Angeles, California
1983 *Los Angeles/New York Exchange*, Artists
Space, New York, New York
1980 *By Products*, Los Angeles Contemporary
Exhibitions, Los Angeles, California
1979 *Watch It! Think It!* (television commercial),
KCOP-TV, Los Angeles, California;
sponsored by Long Beach Museum of Art,
Long Beach, California

LINDA TADIC

1984 BFA, CalArts

Selected Screenings

1987 Filmforum, Los Angeles, California
Projections in Public,
Los Angeles Institute of Contemporary Art,
Los Angeles, California
No-Nothing Cinema,
San Francisco, California

REA TAJIRI

1982 MFA, CalArts
1980 BFA, CalArts

Selected Exhibitions and Screenings

1987 *New Work on Video, Kim Ingraham and Rea
Tajiri*, Film Video Arts, New York, New York
The Rehearsal, Dance Theatre Workshop,
New York, New York
1986 *Nobody Owns the House*, Dance Theatre
Workshop, New York, New York
Women Make Videos, Women's Building,
Los Angeles, California

1983 *"And His Normal Reaction Of Saying Oh This
Is Great You Don't Miss Me, Oh This Is
Great, And That Laugh!!!"*, Lhasa Club,
Los Angeles, California; and Artists Space,
New York, New York
F.A.R. and Richard Kuhlenschmidt Gallery,
Los Angeles

MARY ANN TOMAN

1985 MFA, CalArts

Selected Exhibitions

1986 *Los Angeles Women's Video Festival*, The
Women's Building, Los Angeles, California
Light Years Film and Video Festival, London
Filmmakers Coop, London, England
Film/Video Arts, New York, New York
F.A.R., Los Angeles, California
1987 *NO/TV*, Visual Studies Workshop,
Rochester, New York
Athens Video Festival, Athens, Ohio
New Filmmakers Showcase, Collective for
Living Cinema, New York, New York
Films Charas, New York, New York
Seen Missing, F.A.R., Los Angeles, California

JAMES WELLING

1974 MFA, CalArts
1972 BFA, CalArts

Selected Exhibitions

1988 Solo exhibition, Johnen and Schottle,
Cologne, West Germany
Solo exhibition, Philip Nelson, Lyon, France
Centre d'Art Contemporain,
Geneva, Switzerland
1987 Solo exhibition, Kuhlenshcmidt/Simon
Gallery, Los Angeles, California
Solo exhibition, Feature, Chicago, Illinois
1986 *Rodney Graham/James Welling*,
Coburg Gallery,
Vancouver, British Columbia, Canada
1984 *Allan McCollum/James Welling*,
Cash/Newhouse, New York, New York
1982 Solo exhibition, Metro Pictures,
New York, New York
Trouble in Paradise, A + M Artworks,
New York, New York
1979 *Imitation of Life*, Hartford Art School,
West Hartford, Connecticut

CHRISTOPHER WILLIAMS

1981 MFA, CalArts
1979 BFA, CalArts

Selected Exhibitions

1987 *Nothing Sacred*, Margo Leavin Gallery,
Los Angeles, California
The Castle, by Group Material, *Documenta
8*, Kassel, West Germany
1986 *Rooted Rhetoric, Una Tradizione dell'Arte
Americana*, Castel dell'Ovo, Naples, Italy
1985 *The Art of Memory, The Loss of History*,
The New Musuem of Contemporary Art,
New York, New York
Prina, Stahl, Williams, Marian Goodman
Gallery, New York, New York
*Stephen Prina, Mark Stahl, Christopher
Williams*, Galerie Crousel-Hussenot,
Paris, France
1984 *Jenny Holzer, Stephen Prina, Mark Stahl,
Christopher Williams*, Foundation de Appel,
Amsterdam, The Netherlands, and
Gewad, Gent, Belgium

1982 *74th American Exhibition*, The Art Institute
of Chicago, Chicago, Illinois
Solo exhibition, *Source, The Photographic
Archive, John F. Kennedy Library...*,
Jancar/Kuhlenschmidt Gallery,
Los Angeles, California
1981 *5. International Biennale, Erweiterte Foto-
grafie*, Weiner Secession, Vienna, Austria

LINDA WISSMATH

1984 MFA, CalArts
1981 BFA, CalArts

Selected Exhibitions and Screenings

1987 F.A.R., Los Angeles, California
1986 *The Unoffical New York City Media Festival*,
The Museum of Modern Art,
New York, New York
The Naked Eye Cinema, ABC No Rio,
New York, New York
No Stain Briodur, Hamburg, West Germany
Craft of 16mm Screening, Film Video Arts,
New York, New York

1985 Hudson Gallery, New York, New York

B. WURTZ

1981 MFA, CalArts

Selected Exhibitions

1987 Solo exhibition, Bess Cutler Gallery,
New York, New York
Solo exhibition, Feature, Chicago, Illinois
*Nancy Chunn, Lillian Mulero, Rene Santos,
B. Wurtz*, INTAR Latin American Gallery,
New York, New York
Post-Abstract Abstraction,
The Aldrich Museum of Contemporary Art,
Ridgefield, Connecticut
(of Ever-Ever Land i speak), Stux Gallery,
New York, New York
1986 *Six Sculptors*, Artists Space,
New York, New York
Promises, Promises, Feature, Chicago, Illinois
1984 *Post Olympic Art*, Los Angeles Contempo-
rary Exhibitions, Los Angeles, California; and
Galerie Beau Lezard, Paris, France
1981 White Columns, New York, New York

MEL ZIEGLER

1982 MFA, CalArts

Selected Exhibitions and Public Works

1987 *Real Pictures*, Wolff Gallery,
New York, New York
Nature, Feature, Chicago, Illinois
Time The Destroyer Is Time The Preserver,
Loughelton Gallery, New York, New York
1986 *Stones Have Been Known to Move*, White
Columns, New York, New York
*If You Would See The Monument, Look
Around*, Central Park, New York, New York;
sponsored by Creative Time, Inc., and
Central Park's Summer Stage in collabora-
tion with the New York City Department of
Parks and Recreation and Central Park
Conservacy
House Monument, Los Angeles Institute of
Contemporary Art, Los Angeles, California
1985 *Garden Sculpture*, Ward's Island, New York,
New York; organized by A.R.E.A.
Unplanted Landscape, Bellport, New York
Art and the Environment, Lever House, New
York, New York; organized by A.R.E.A.
1984 *Instant Landscape*, Artists Space,
New York, New York

3587